ARGYLL

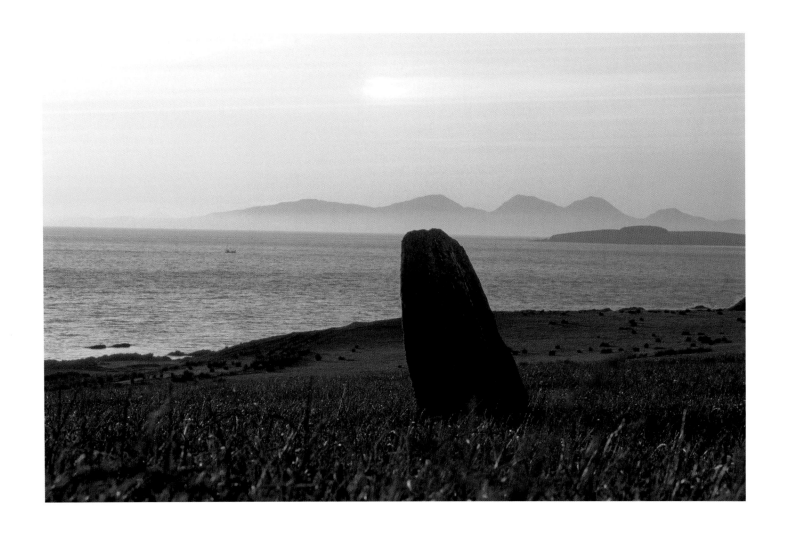

Standing stone and Jura near Tayinloan, Kintyre

ARGYLL

PHOTOGRAPHS BY
ALLAN WRIGHT

WITH AN INTRODUCTION BY
MICHAEL RUSSELL

First published in Great Britain in 2005 by

Birlinn Ltd
West Newington House
10 Newington Road
Edinburgh

www.birlinn.co.uk

ISBN10: 1 84158 355 3
ISBN13: 978 1 84158 355 6

British Library Cataloguing-in-Publication Data
A catalogue record for this book is available on request from the British Library

Design by Andrew Sutterby

Printed and bound by L.E.G.O., Italy

PREFACE

THE DAY BIRLINN offered me the job of covering Argyll for a photographic book was a good day for me. As a landscape photographer, getting under the skin of distinct places such as this is what I love to do and as Argyll is a fantastically beautiful place and also the land of my birth, I thought for about 15 seconds and said yes. The expression *nice work if you can get it* is one often used about landscape photography and this job probably best confirms that notion.

The material in this book was sourced from essentially two separate shooting projects - last year 2004 and also the early 90,s when I first ventured out in an antique camper van to get to grips with this great county. In landscape terms it has not changed much over this time but I do sense it has grown more conscious of both its own inherent beauty and its individuality.

I could talk forever about the joys of taking photos on the west coast of Scotland but not being a writer I will let the pictures tell their own story. However I will take this chance to thank the many people and acknowledge the spirit of the places that made this piece of work happen.

I thank in particular all the nameless but wonderfully alive people, sane and otherwise, I met whilst on the land — I call them *15 minute people* which may sound diminishing but that is not how it is intended.

Over the years of pounding various trails I have really come to value the spontaneous openness that arises from encounters in the Scottish landscape with these people - they so often made the moment or even the day — we are the fraternity of explorers I suppose. I also want to thank all sorts of other places and people. Places like Tighnabruaich for being so essentially West Coast, Glen Lonan for blowing me away at first visit, Dunoon for being the same place I recall from my infancy (but please bring back the little wooden motor boats to hire on the beach), Loch Awe for being, well, awesome, Linda McCartney for her devotion to South Kintyre, The Highland cow at Keilmore Point for appearing at the right moment with perfect nonchalance, to the helpful people at Crarae Gardens for their superlative spring garden, the Crinan Coffee Shop for its consistent support and sustenance, the good people at Keilmore Farm for kindly resuscitating my van, the Ferryman at Easdale for getting me to the right spot just in time, Loch Lomond Seaplanes for their enthusiasm for landscape enjoyment from the air, the world class Kilmartin House Museum for their soup and their role in intensifying my interest in Kilmartin Glen, the lovely Swiss lady with the utterly convincing theory about the nature of the cup and ring marks at Achnabreck, all my commercial customers for having faith in my work, Hugh Andrew at Birlinn for his confidence and for knowing what he

wanted, also to Jim, Liz and Laura at Birlinn for their patience and support.

A special mention also goes to my mother Margaret for supporting me all the way and for having the excellent idea of giving birth to me in Dunoon, Argyll. Thanks also to my faithful little van for tirelessly enabling me to wake up in some of the most beautiful places known to man and last but not least thanks to Tara the smartest small Labrador ever, for her special companionship and our love of hunting (her quarry being olfactory, mine visual). Together our quest has been to encounter the land of Argyll, if possible find its beating heart, report back and spread the word.

Allan Wright

INTRODUCTION

MANY OF THE PHOTOGRAPHS in this book – from Allan Wright's extraordinary perspective on Inveraray, in which its hinterland is not earth but water, to his west coast studies in which the paps of Jura are ever present on the maritime horizon – are studies of the sea, or of land in proximity to the sea.

That is no accident. Yet it may not be deliberate either, for in order to ignore the sea in Argyll, you must consciously turn your back on it. It is everywhere: shimmeringly visible from the peaks of the highest mountains; tantalisingly framed by the rocky sides of passes; flowing fast in the narrows between islands; reaching up in storms to spray ruins beside cliffs; lying calm or flexing white muscles in lochs beside roads; rolling out, horizon straight, to dark masses of distant islands; rising and falling in rubbish strewn greasy swells below concrete fishing piers.

Argyll values its earthbound link, and sometimes flaunts it. Yet Argyll is always land and water – land raised up and pushed towards Scotland, water that flows out towards Ireland and the Atlantic.

Surprisingly, most of the inhabitants of this marine environment hardly use the sea at all. They may, from to time, travel on a small ferry that takes twenty minutes to get from one side of the Clyde to the other, or less than two to cross the Kyles of Bute.

Some drive lorries to the ports that fringe the county and are carried slowly by ship to Islay or Colonsay or even further afield. But these are exceptions rather than rules.

Our modern reluctance to engage with the maritime is comparatively recent. Stand on any hillside in Cowal and look southwards. On days when the rain is not falling and the haze has not risen, Ireland is a faint smudge which your eyes strain to see. But in Kintyre the line is more defined, and the detail only just out of sight. A mere twenty miles separate Scotland and Ireland at this point, and to our ancestors twenty miles of sea-scape was a journey of a day, and a far easier one than its boggy, rutted equivalent on land even if sea-borne. Sea-borne journeys are, naturally, not without hazard. Beneath the waves and by the rocks there are many wrecks, long since smashed to pieces. There are days when to embark would be foolish, and to arrive unlikely.

Of course place-names themselves testify to the power of the sea-ways. Although Gaelic predominates, it mixes often with Norse, and it was the Vikings who made these places their own because of their mastery of the longboat. Their kingdom of Sodor and Man – the South country – and their slow settlement of the islands and inlets was dictated by the flow the sea and eventually came to an

end on the sea with defeat at the Battle of Largs. Thus the sea was a conduit of power, and its possession gave influence and control. It was the determining factor in securing dynasty and pre-eminence.

The sea as thoroughfare and the sea as the source of income and sustenance are both co-joined ideas and indeed necessities. The many castles of Argyll, even those that lie inland, have water lapping close to them. That was certainly a defensive strategy, but it was also pragmatic. It made it easier to take the basic building materials, the supplies, the defenders and even the prisoners by sea. And it was easier to remove the corpses that way, as the island or shore side burial places of kings, dukes and commoners all show.

The sea not only carried people and food, it gave food too, as well as being the means by which the other requirements of life were transported. Freshness was secured only by proximity, and how much more proximate could one get than living on the shore, or a stone's throw from it? (Though if things were too heavy or numerous to be loaded on fragile craft, then there were other ways to transport them. The drove roads of Argyll, for example, start on the shores of the Kyles of Bute.)

The greatest days of sea transport, though, occurred much more recently. The democratising effect of steam transport revolutionised not just land journeys, but sea journeys too, securing, as Kipling put it in *McAndrew's Hymn* – that pean of praise to the maritime engine – 'Interdependence absolute, forseen, ordained,

decreed'. The huge growth in traffic on the Clyde and to and from the islands which took place from the middle of the 19th century onwards created a mobility which, whilst contributing to the ease of emigration, also contributed to an improvement in the quality of life.

The Edwardian middle-class summer visitors to the seven sisters, the holiday houses built at Colintraive by an enterprising builder, would decamp by fast steamer to their temporary retreat and make the short stroll to their journey's end from the pier that overlooked Rhubodach. Their luggage might come later, courtesy of the mail boat. Merchants from that mercantile city of the Empire, Glasgow, would set out on a sunny morning to travel the short distance from their homes in Dunoon, Kirn and Kilmun, knowing that they could be in the centre of Glasgow in an hour, crossing with the tidal wave of the urban poor who were on their way for a brief glimpse of what life was like 'doon the watter'.

No celebration of the sea around Argyll would be complete without the image of the puffer, carrying its myriad of cargoes in and out of the sea lochs. And no celebration of the puffer could fail to include the inimitable figures of Para Handy – Captain Peter MacFarlane, with his rag tag crew, charming and blustering their way from Cowcaddens to Crinan, and getting involved in all sorts of scrapes along the way.

But the puffer was not just all 'high jins larks' as Para would have put it. They were the workhorses of the community, landing grocery supplies ordered by letter from Glasgow, coal twice a year to a

place where the community could buy it, and everything and anything else required. There is simply no modern integrated system of distribution that can compare: the hundreds of vans and lorries speeding around the area provide less satisfaction and much less service.

Road transport may now be the only rational way to move things and people from A to B. But the fact remains that any journey from A to B in Argyll – from Airdrishing to Bowling, from Arrochar to Bowmore, from Ardlamont to Bute – these days is usually by way of C, D and E as well. On water it is much more direct.

By sea Argyll is, in itself, always on the way to somewhere else. The sea road is never a dead end or a cul de sac. A delivery for Tiree can easily call in, *en passant*, at Tighnabruaich to on- or off-load, and carry on to Tarbert. A boat of supplies for Stornoway can hove to at Sandbank or Southend without adding much to its journey time or the cost of passage. What is more, it can do so with less damage to the environment and, if not quicker, then not much longer. Fast boats and ferries can in fact save time and be more direct as well.

The Orkney poet George MacKay Brown described his fellow islanders as 'fishermen with ploughs'. That balance is harder and harder to find in the people of the west of Scotland, where the plough or the heavy lorry (and always the car) is the norm and where the boat, the outboard motor and the oar is the exception rather than the rule.

But something else lies closer to hand even though the people of the landscape are largely blinded to it. Our love affair with the internal combustion engine has taken us out of our element and stranded us on a dry land increasingly polluted with petrol fumes and increasingly stalled by congestion and a crumbling infrastructure.

Allan Wright's photographs show Argyll as it is. Certainly there are imposing landscapes and attractive ruins. Tractors do rot away in fields of ferns and there are farms – and many of them – that nestle under hillsides.

Yet as human beings we are made up mostly of water. Our ancestors cried out with amazement and delight as they breasted hills and saw the blue beyond. It is, therefore, time for us to rediscover it for ourselves and to go voyaging out, making use of what is lapping at our feet

Argyll means 'the heartland of the Gael'. The Gael came here from across the water, in little craft that carried our culture and our future within them. We should never have abandoned them and, when we rediscover them, our world – even this little patch of it on the fringes of the fringe – will be the better for it.

Michael Russell

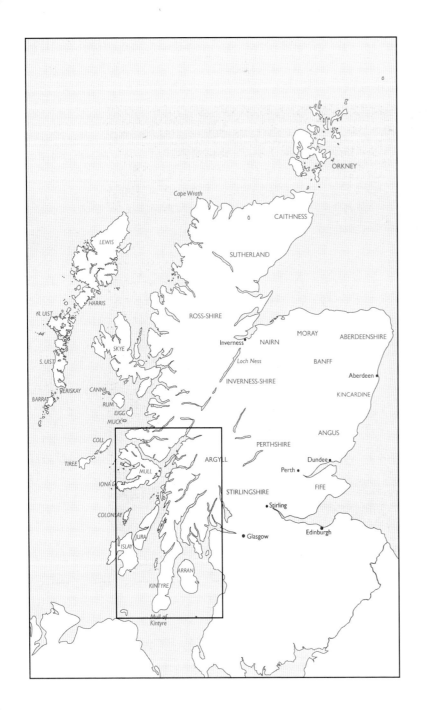

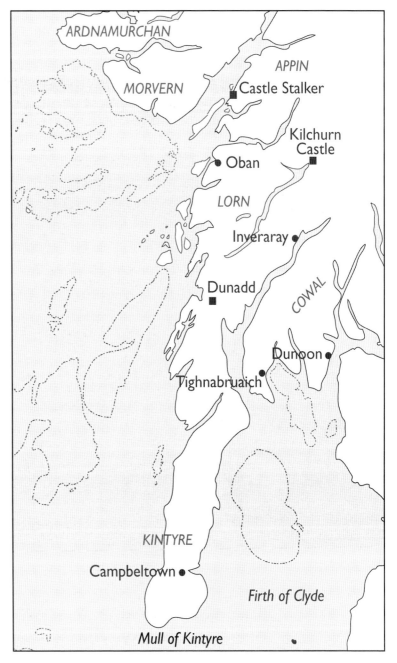

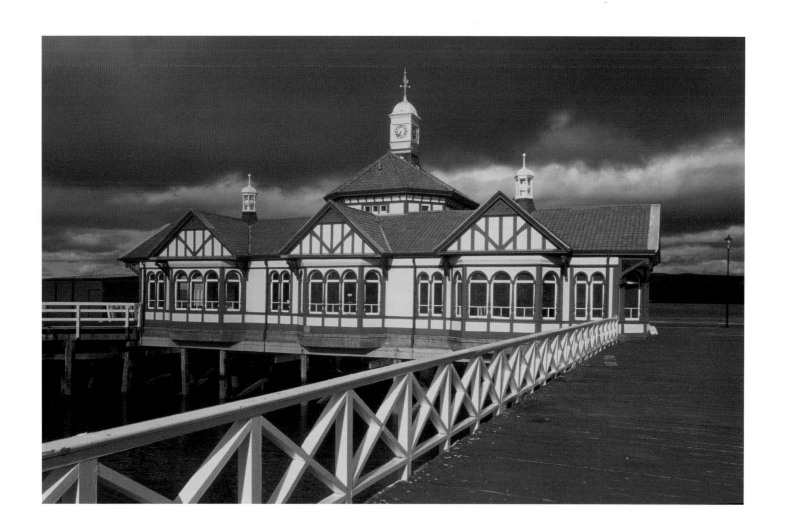

Dunoon Pier now sheltered by a new breakwater and less susceptible to storm damage. It celebrated its centenary in 1998 but which still needs much restoration despite its daily use by the Gourock/Dunoon ferry.

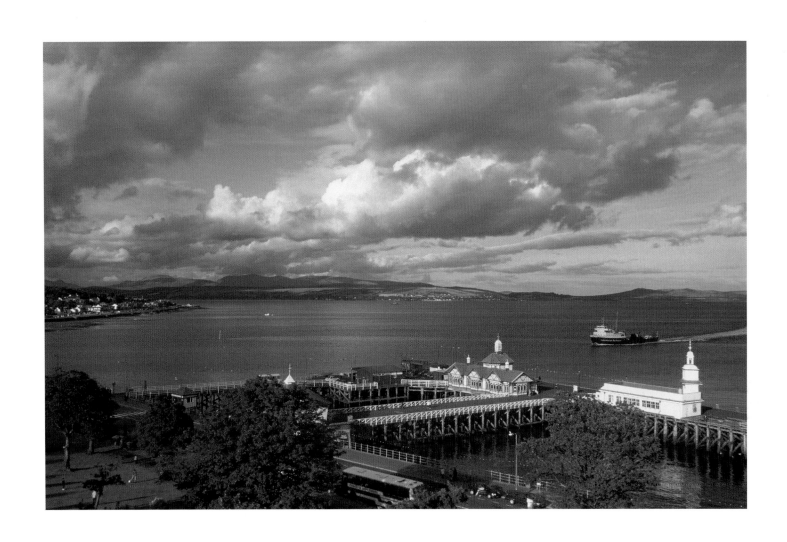

Dunoon from the monument to Burns's lost love, Highland Mary

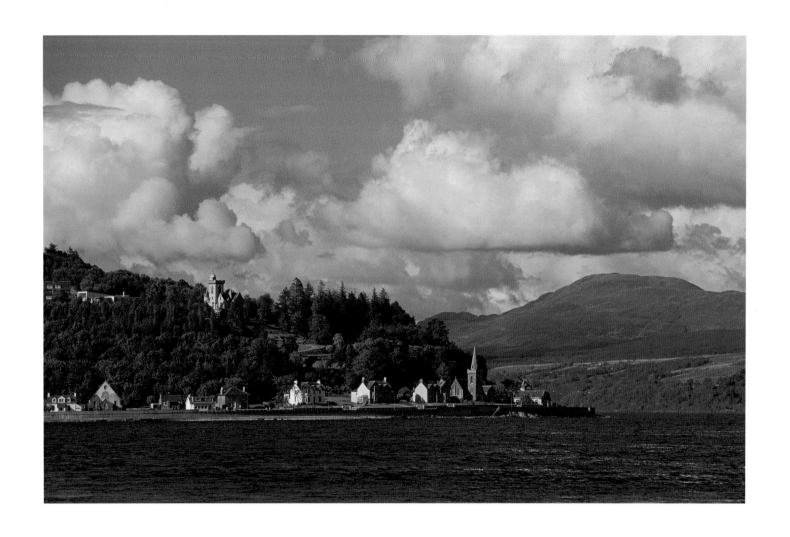

Kilmun – originally the "Church of St Mun" – now a village across the Holy Loch from Dunoon

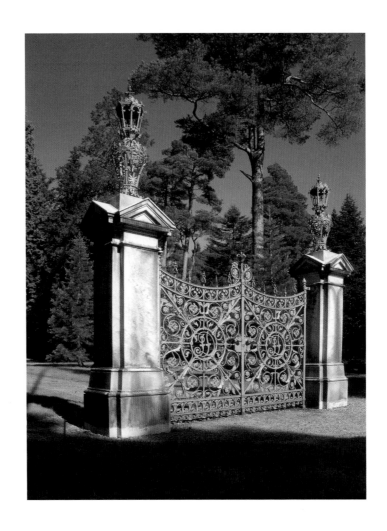

The gates at Benmore Botanic Gardens, seven miles from Dunoon. An outstation of the Royal Botanic Gardens in Edinburgh,its 140 acres contains the national rhododendron collection as well as an abundance of flowering trees and unusual plants.

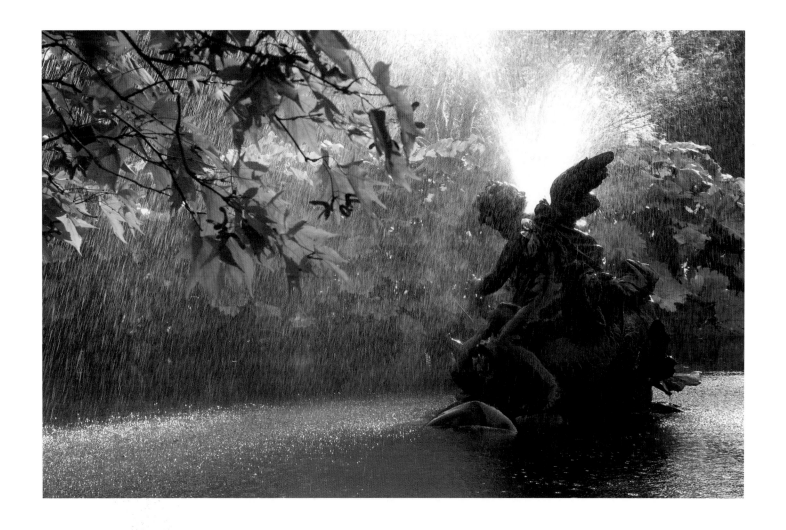

The fountain at Benmore Gardens

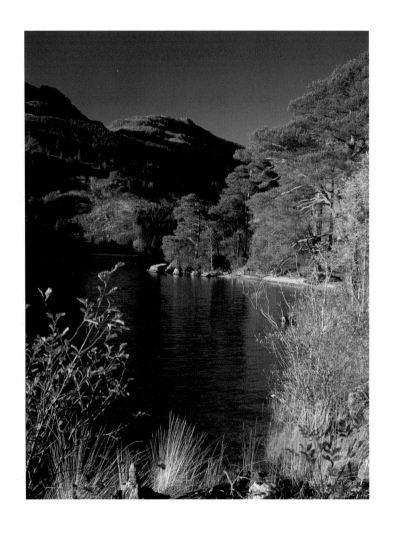

Loch Eck from Jubilee point: this small inland loch between Dunoon and Strachur was once part of a ferry route that took travellers from Glasgow to Inveraray and on to Fort William

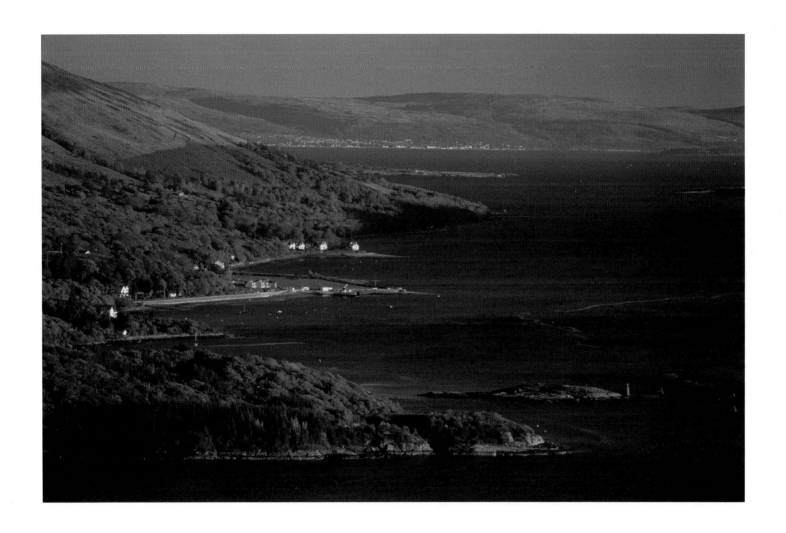

The Kyles of Bute looking to Colintraive. The village lies at the narrowest part of the Kyles and was where cattle were swum across from Bute on their journey to market. A small vehicle ferry crosses constantly today, taking less than 3 minutes.

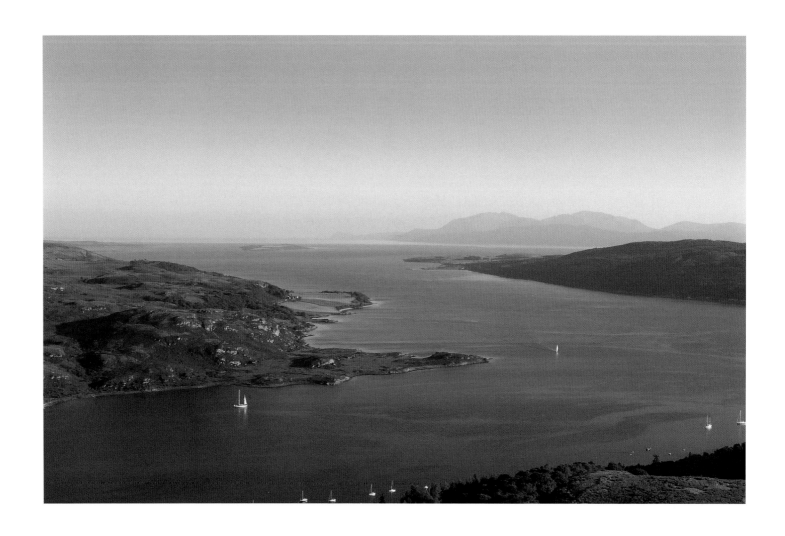

The eastern end of the Kyles of Bute from above Tighnabruaich

Summer brings a profusion of wild and cultivated flowers to cottage gardens, like this one in Glendaruel

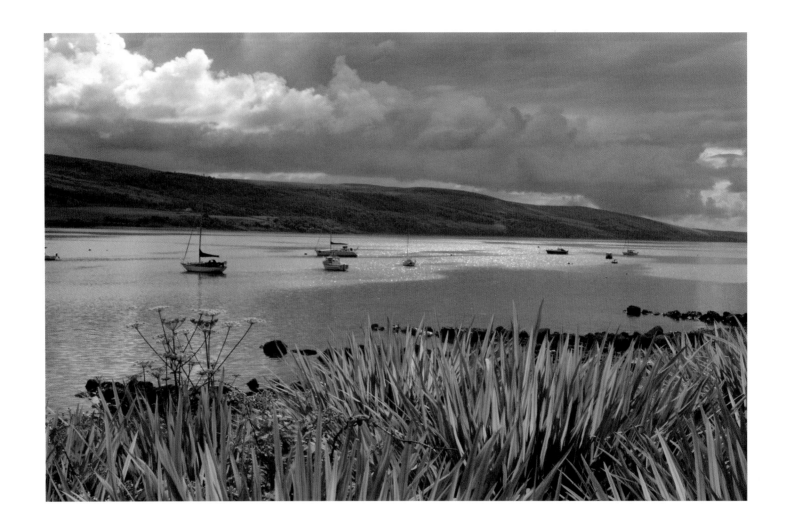

Kames

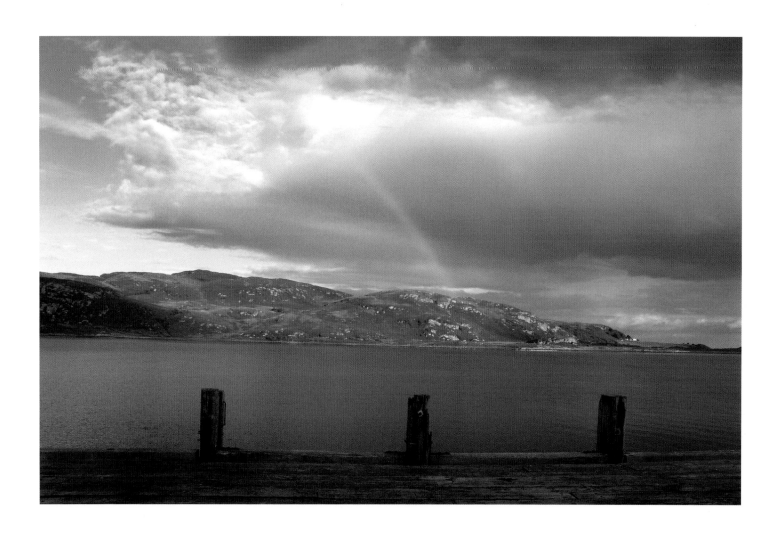

A rainbow at Tighnabruaich Pier – the name of this place facing the Bute means "House on the brae" and the attractive village is now a popular retirement destination, particularly for those who sail

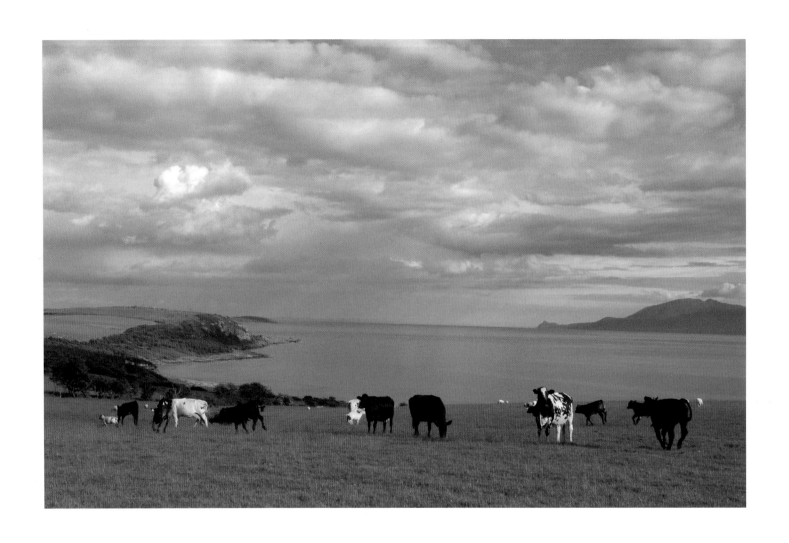

Ardlamont Point; the southern most extremity of Cowal which looks across to Bute and Arran as well as over Loch Fyne

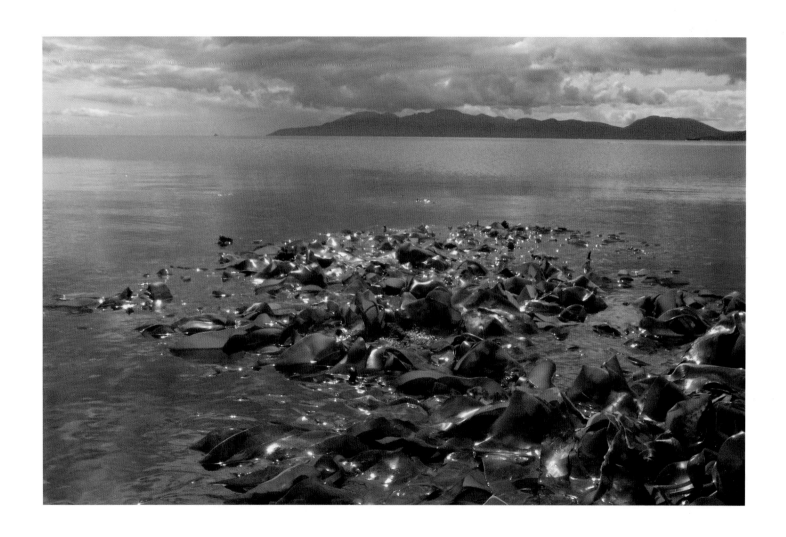

Ascog Bay, near Portavadie. Kelp luxuriates in the clean and warm waters of Loch Fyne.

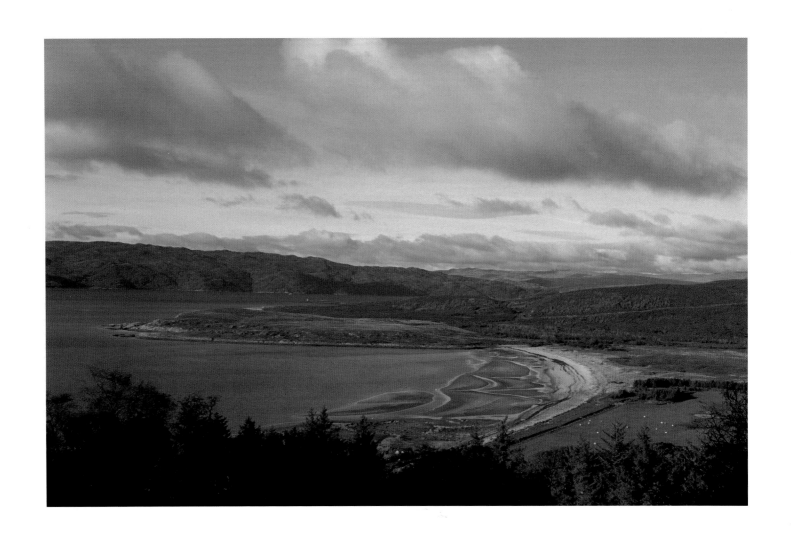

Kilbride bay, south west Cowal. The name again suggests it was the site of an early church.

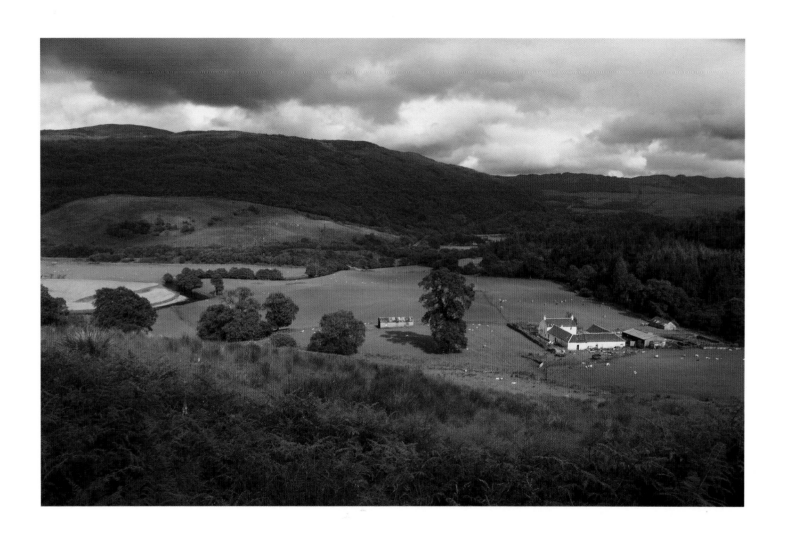

Glendaruel Farm

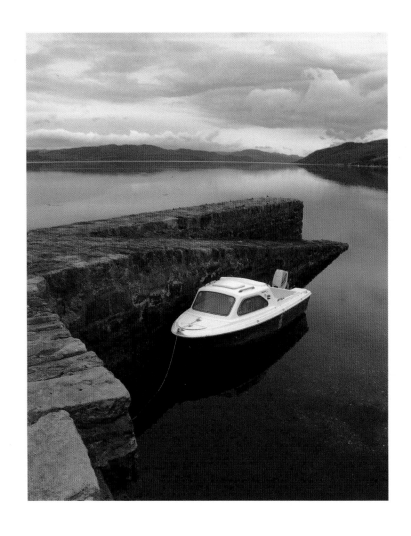

Grey sea and sky at Otter Ferry. "Otter" is a corruption of the Gaelic "oitir" which means a spit of sand. Such a spit is the main feature of the seascape at this point on Loch Fyne.

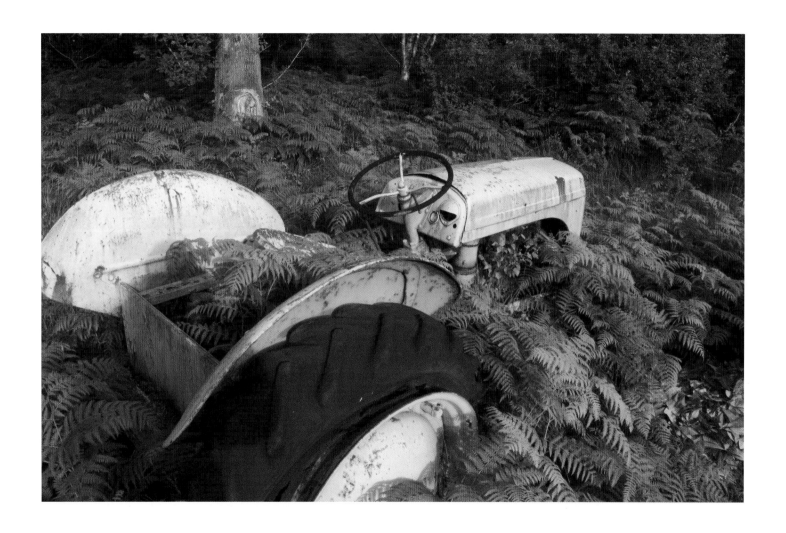

Dead tractor returns to nature - Newton, Cowal

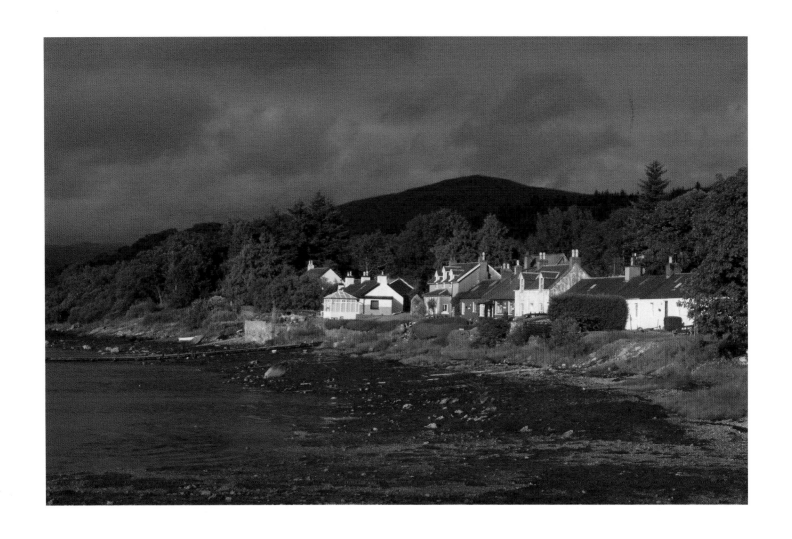

Newton village in a late burst of sun, breaking through a stormy sky. The ever changing colours of Argyll have inspired many painters, including Don McNeil and Jean Bell who live and work in this village.

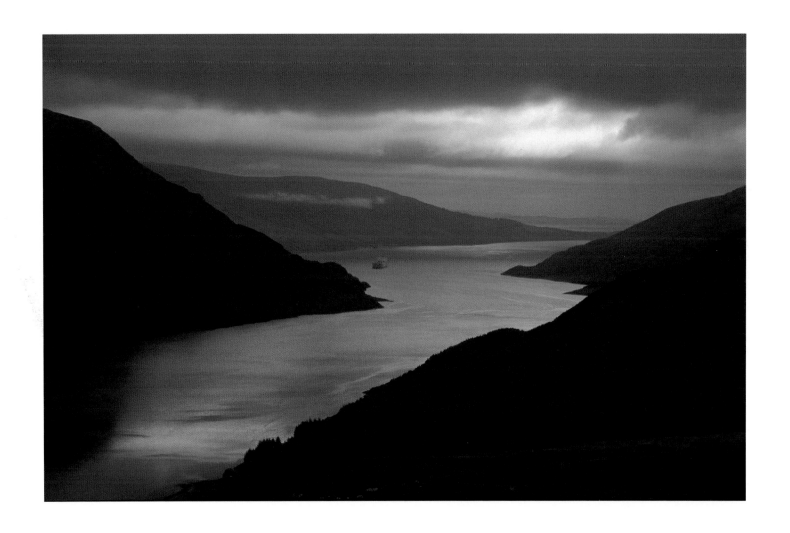

Loch Striven, taken in 1997 when a number of large and surplus to requirements tankers were, from to time, moored in the deep water of its entrance, opposite Rothesay

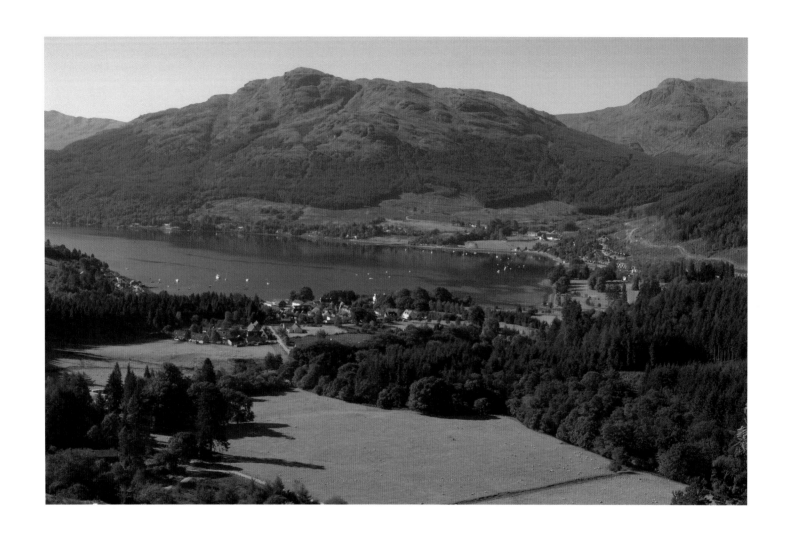

Lochgoilhead, another retirement haven, only an hour from Glasgow

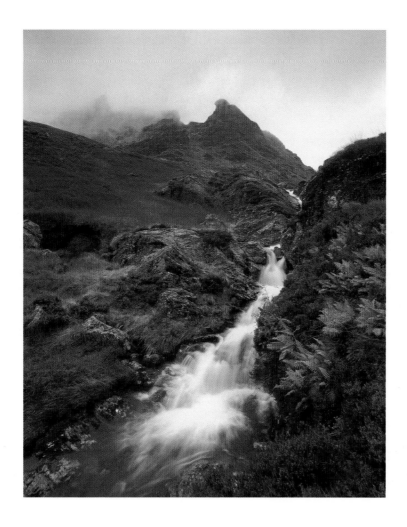

The Cobbler near Arrochar, in rain but with a hint of better weather to come

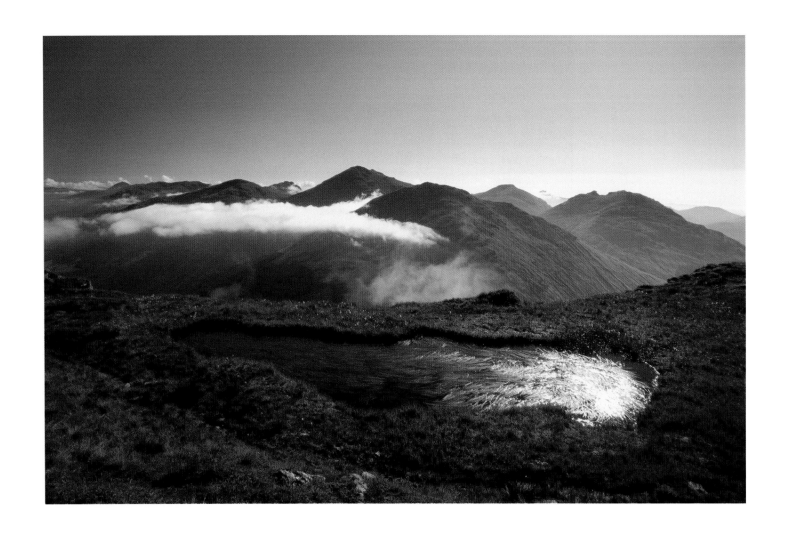

The so-called "Arrochar Alps" seen from Ben An Lochain

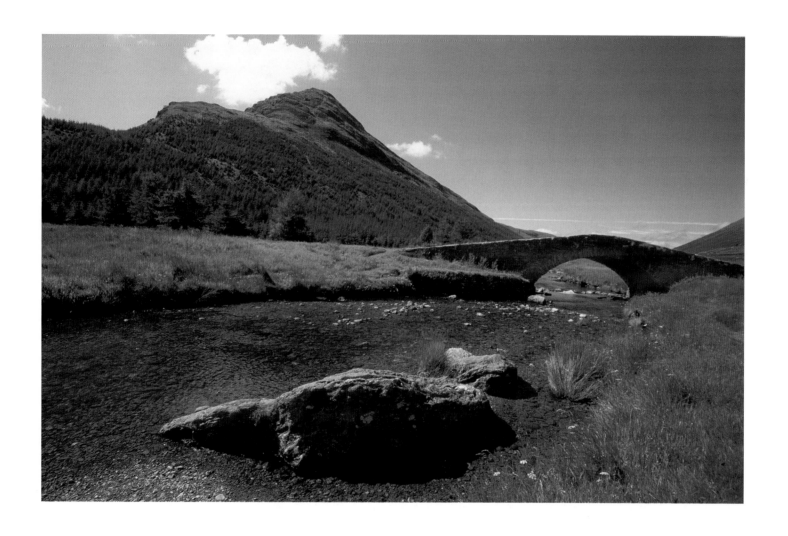

Old Military Bridge, Glen Croe – part of the Hanoverian road network which allowed military forces occupying the Highlands to move around speedily.

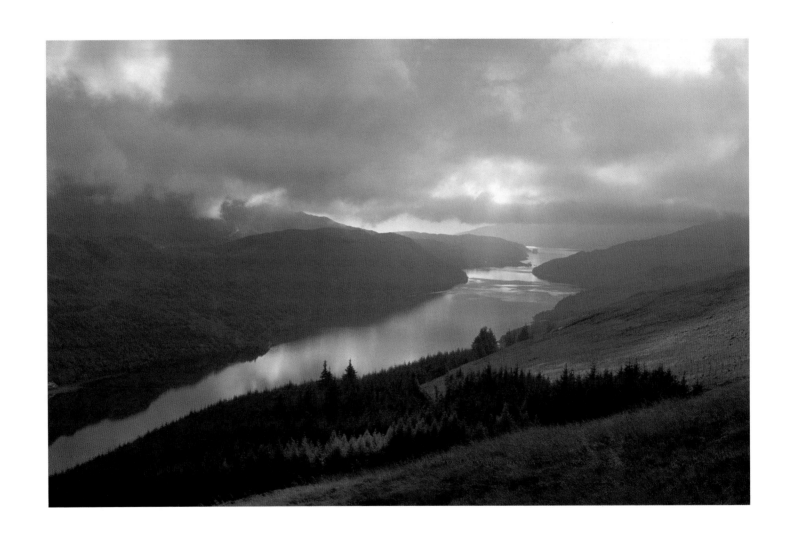

Loch Long from the well worn track up Ben Arthur better known to generations of Glasgow outdoor enthusiasts as "The Cobbler"

Ardkinglas Garden; yet another superb Argyll woodland garden, containing a fine collection of conifers

Ardkinglas Gardens in early summer

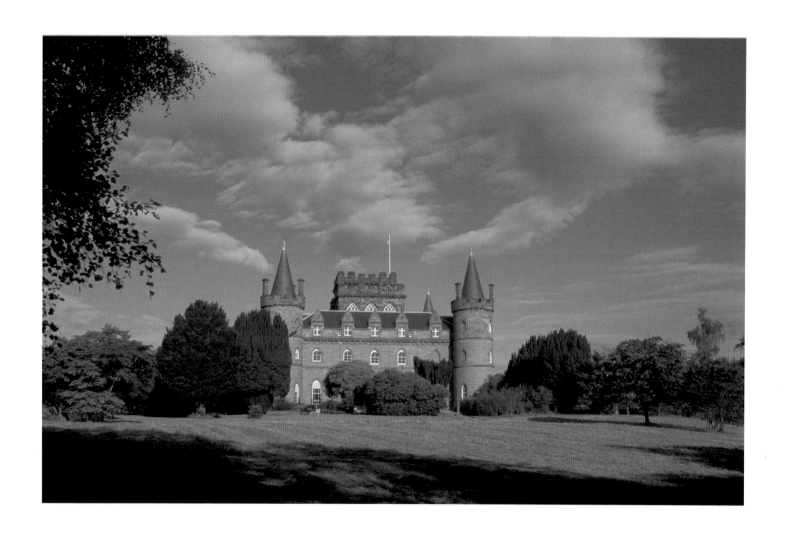

Inveraray Castle, the seat of the Dukes of Argyll, although the town is no longer the administrative and legal centre of the county

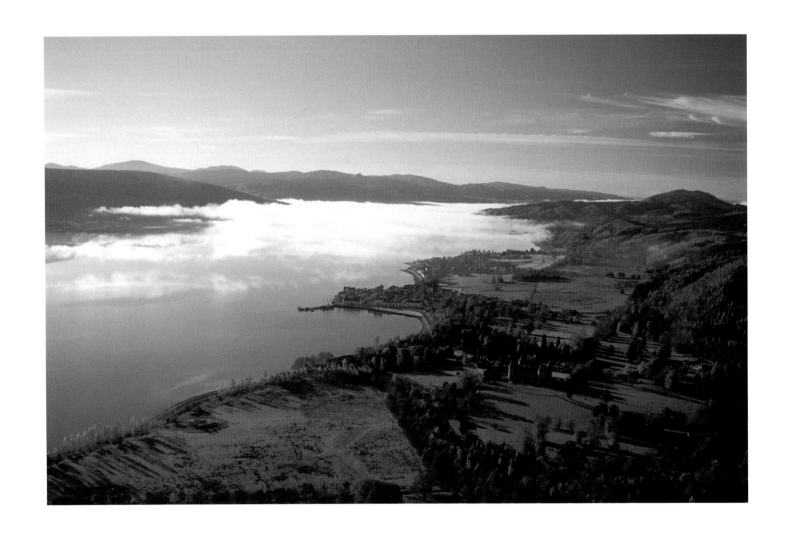

Loch Fyne at Inveraray, from the folly on the top of Dun na Cuaiche

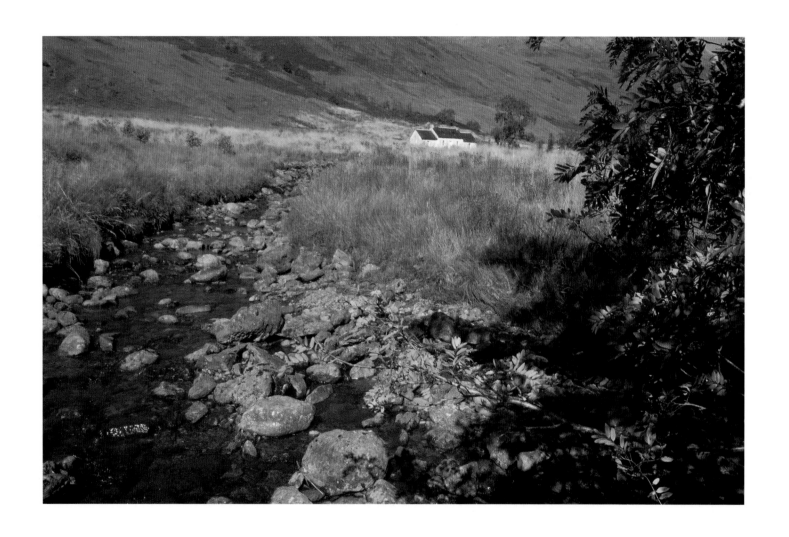

Inverchoracan cottage, Loch Fyne

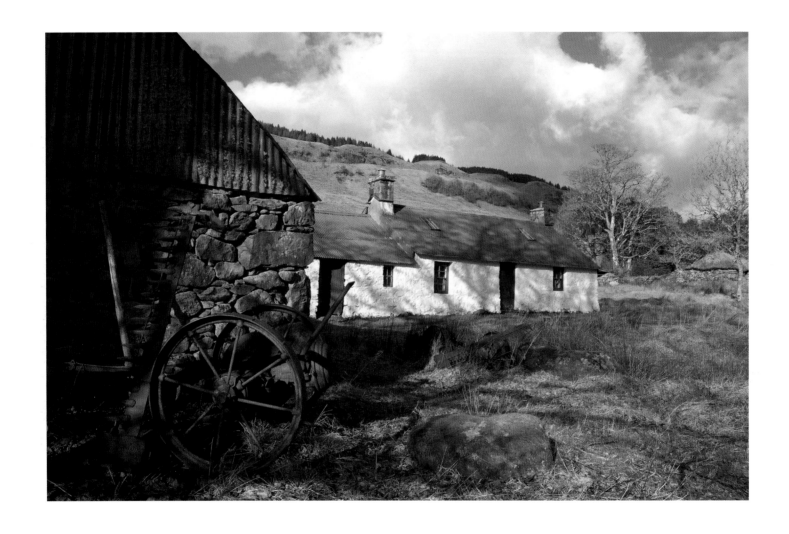

Auchindrain near Furnace – now an open air museum, giving a rare chance to see a substantially restored traditional highland township

Crarae gardens – imported maple and eucalyptus thrive in Argyll along with the native bluebell

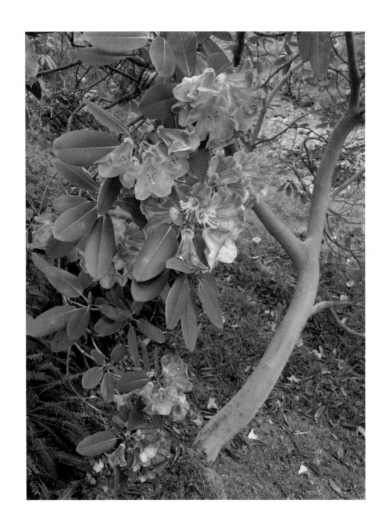

One of the many varieties of rhododendron which flower at Crarae Gardens during May

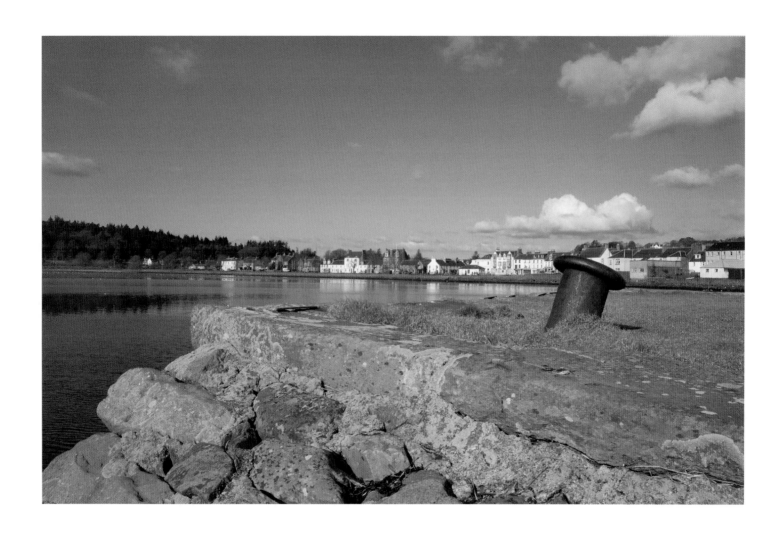

Lochgilphead, now the administrative capital of Argyll

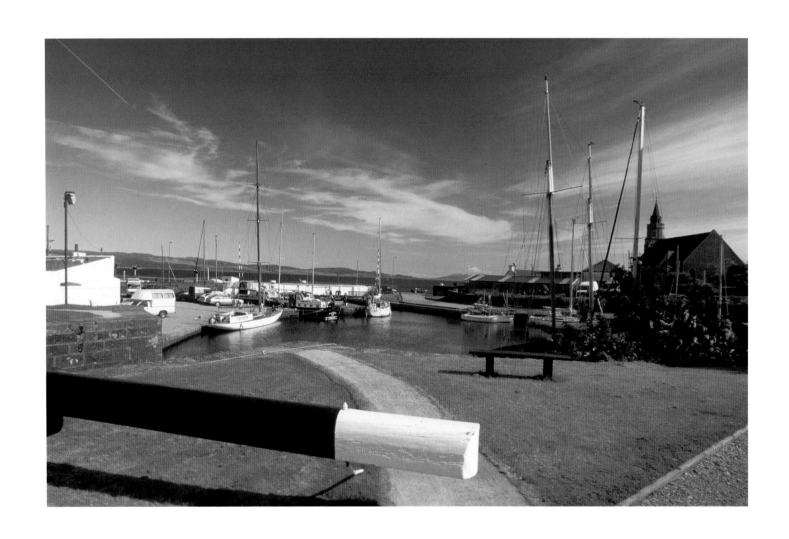

Ardrishaig Locks; the Loch Fyne end of the Crinan Canal, often described as the world's most beautiful shortcut

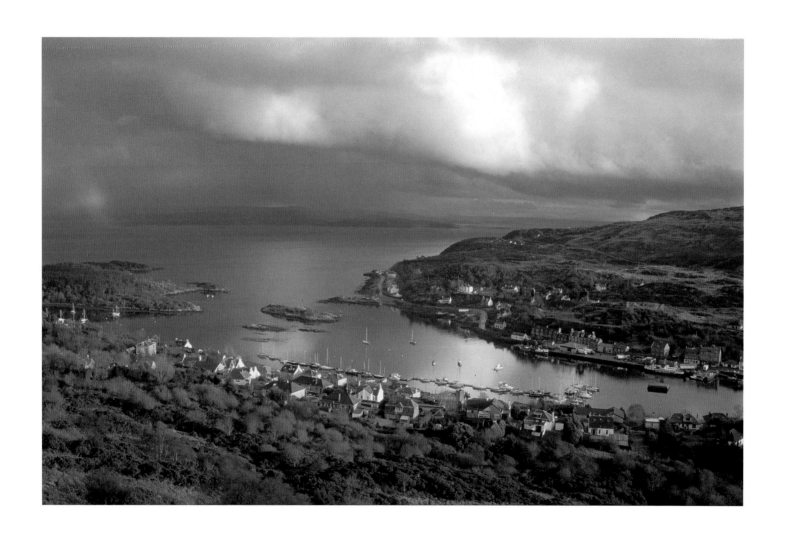

Tarbert in winter, with snow laden skies approaching from the east

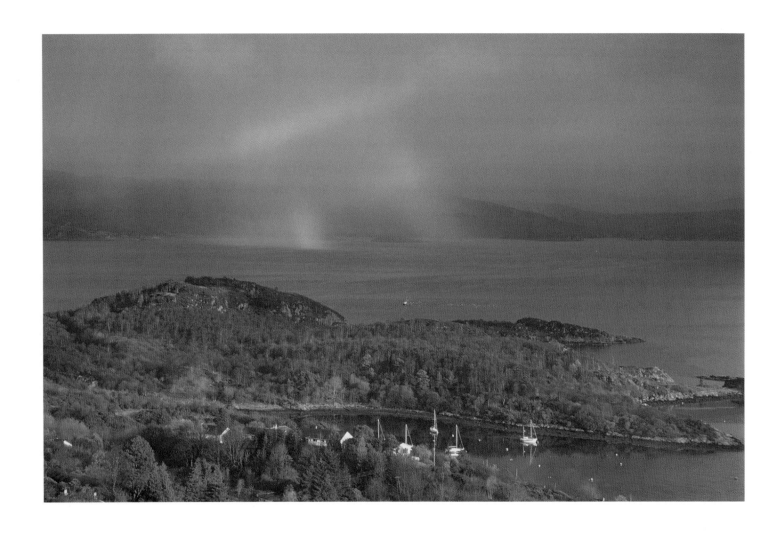

East Loch Tarbert rainbow

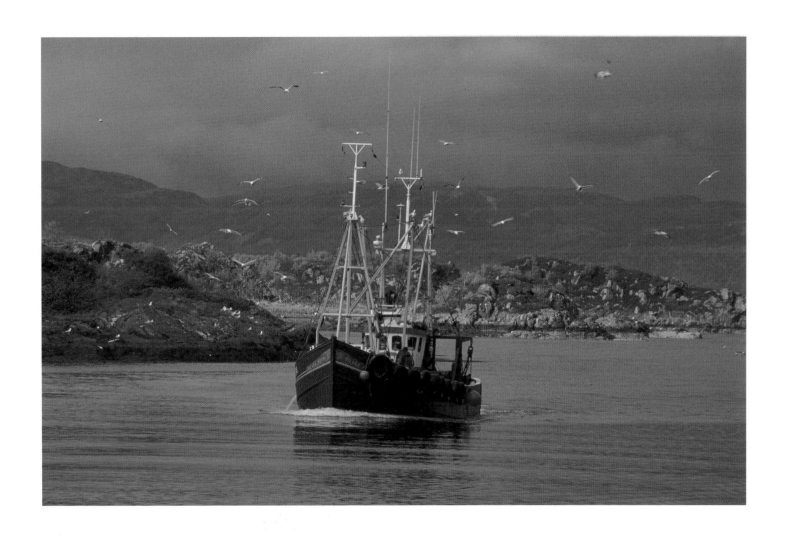

On its way to sell the catch – East Loch Tarbert

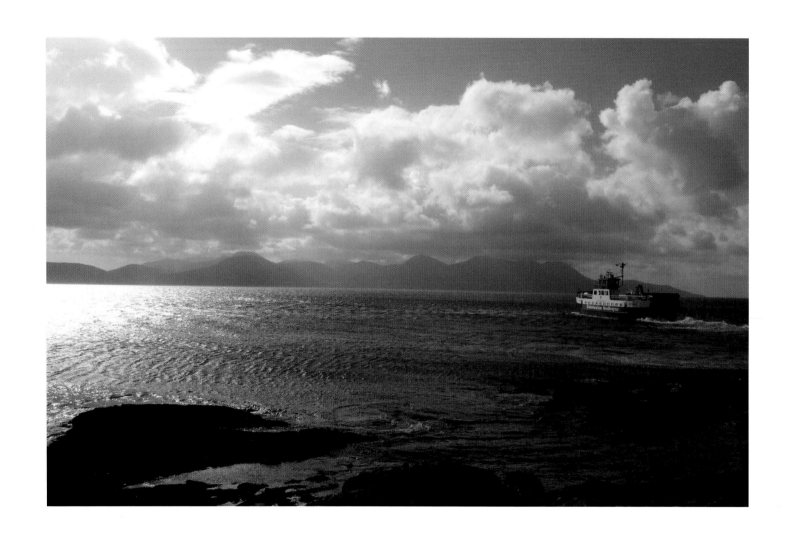

The Lochranza (Arran) ferry, a summer only service, leaves from Cloanaig by Skipness

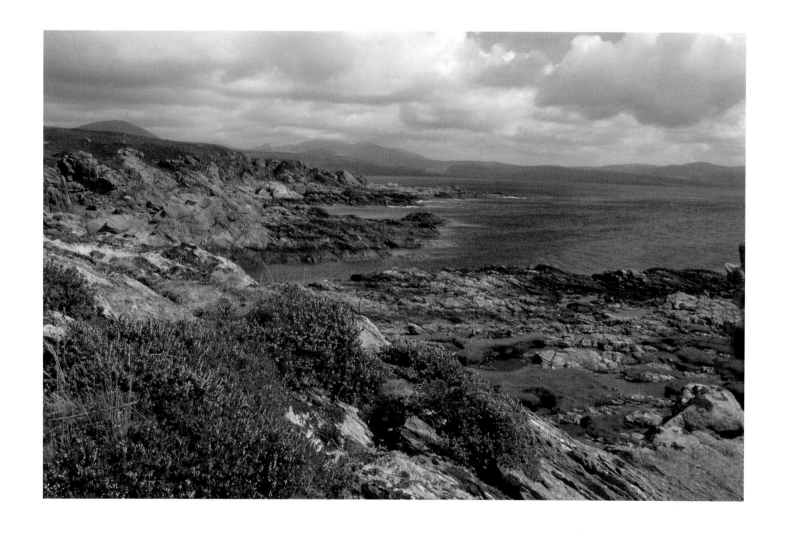

Carradale Point nature reserve

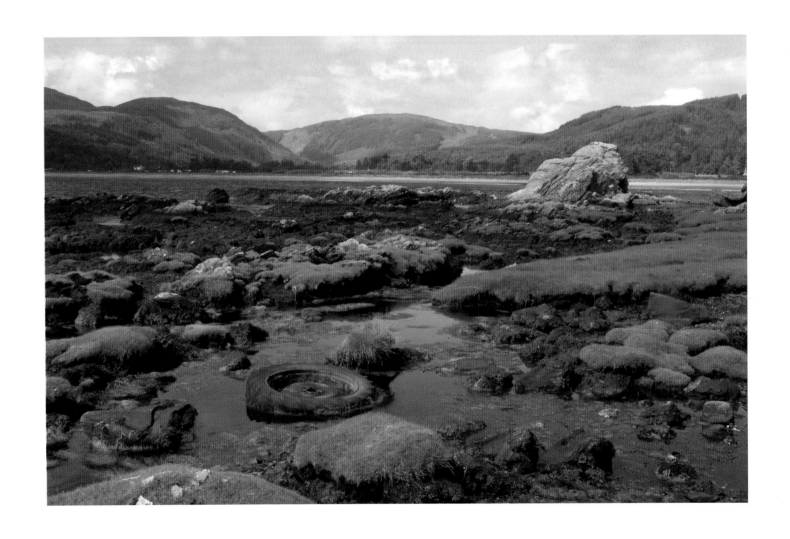

Debris at Carradale Point, Kintyre. The prolific and long-lived author Naomi Mitchison lived in Carradale House from 1937.

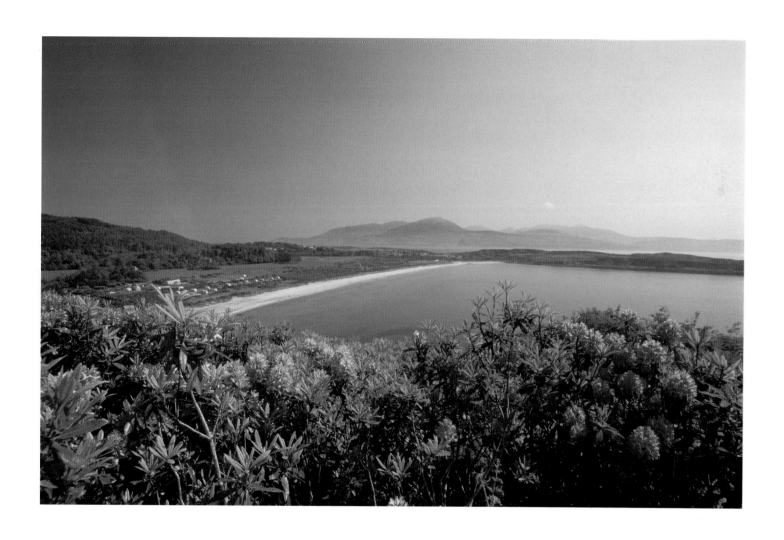

Carradale Bay in late spring: this side of the Mull of Kintyre is sheltered and fertile

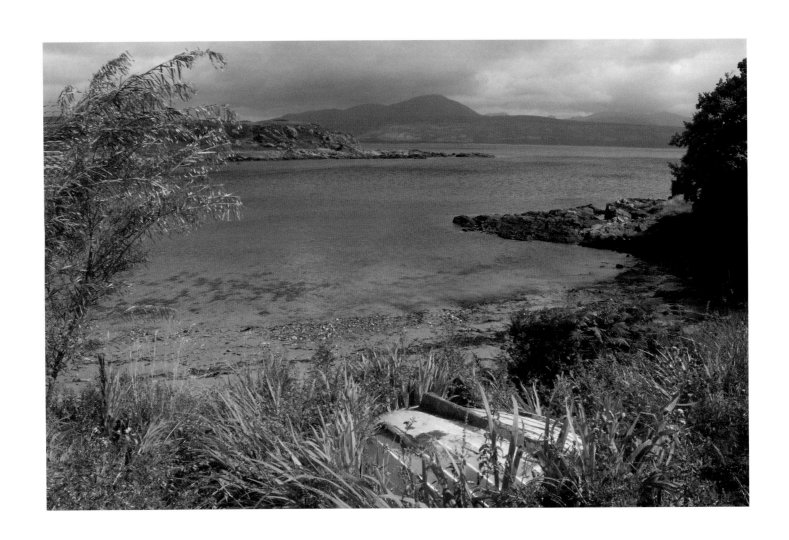

Port Nigh by Carradale, with wild montbretia growing in abundance

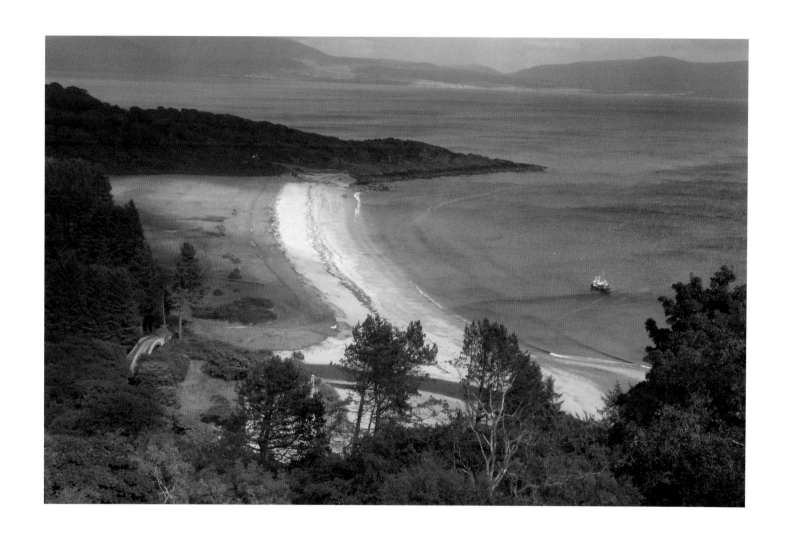

Saddell Bay, Kintyre

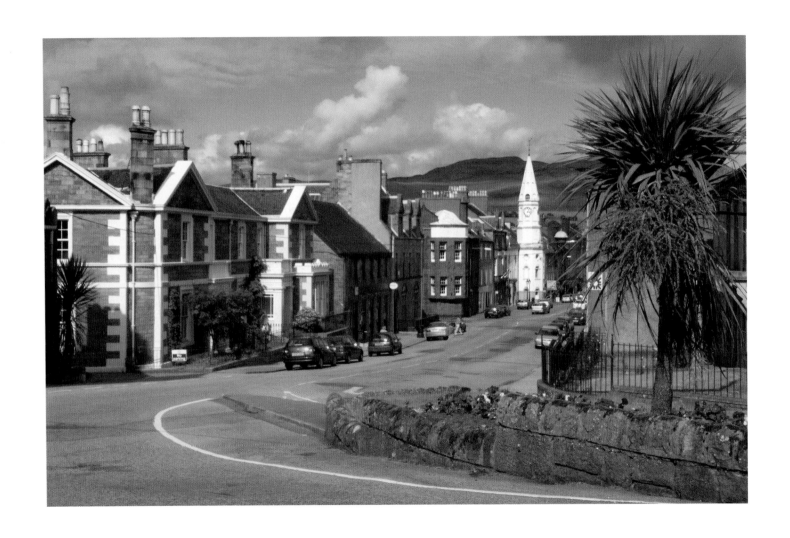

Campbeltown, one of the remotest towns in Scotland, has suffered much economic neglect in recent years and lost much local employment

The tranquil and moving Linda McCartney memorial garden in Campbeltown: Paul's famous "Mull of Kintyre" celebrates the couple's long association with the area

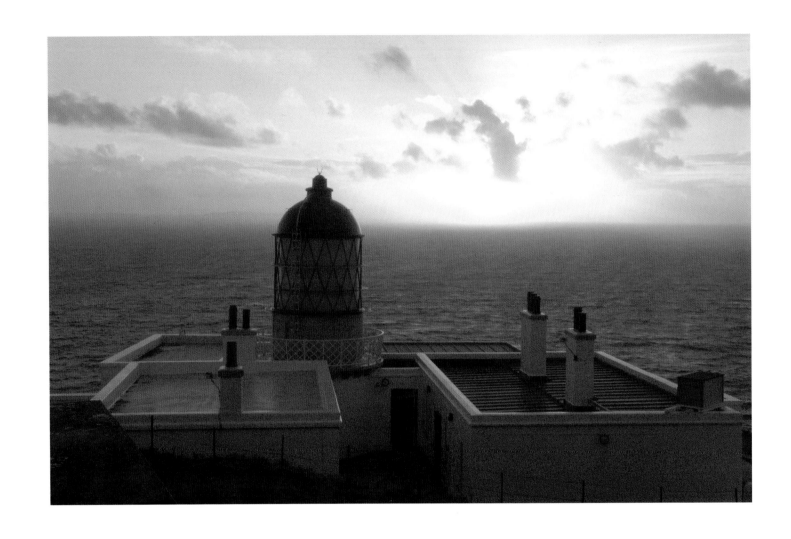

The Lighthouse at Mull of Kintyre – now a self-catering tourist facility, as all Scottish lighthouse are automatically and remotely operated

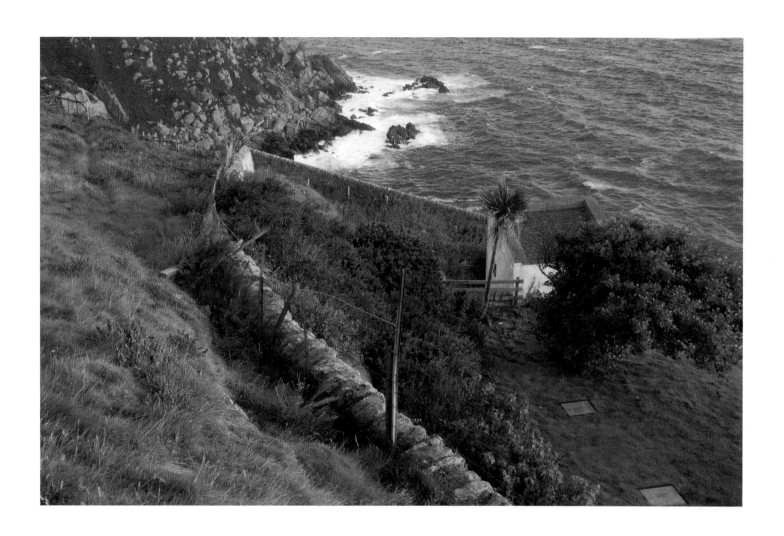

Former lighthouse keeper's garden, Mull of Kintyre

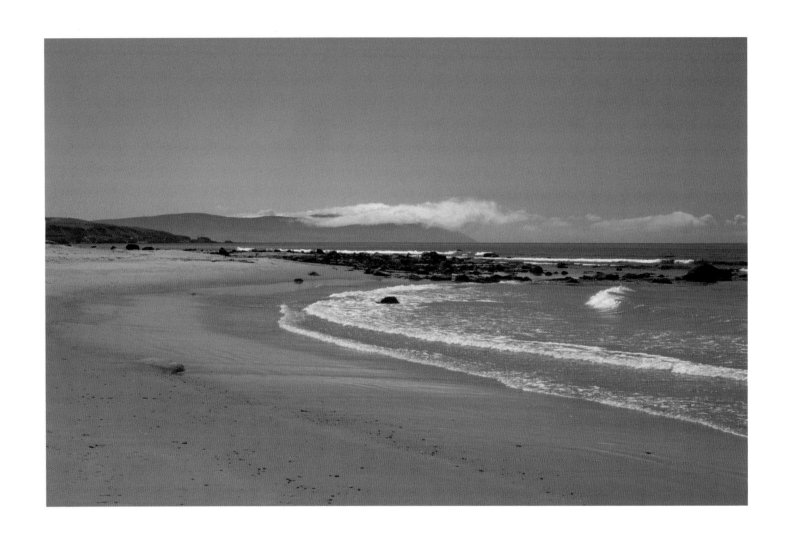

Early morning mist lifting from the Mull of Kintyre above Machrihanish

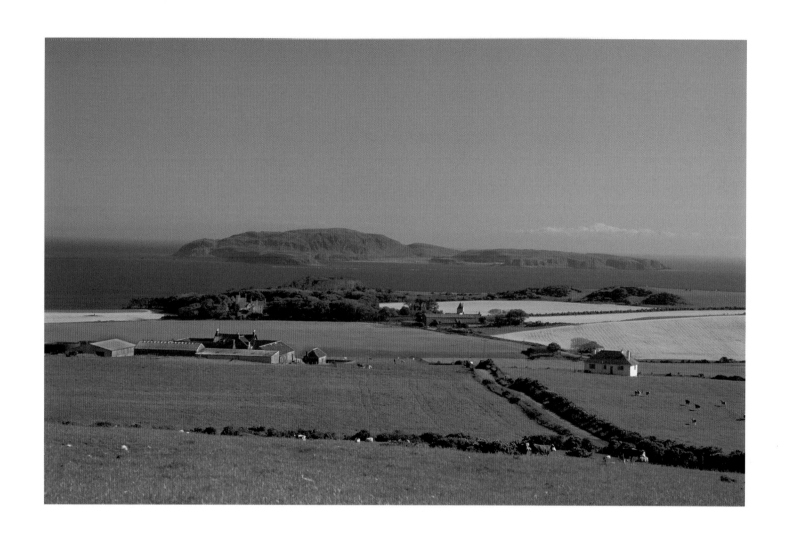

Sanda island at the tip of Kintyre. Sanda now has a thriving pub!

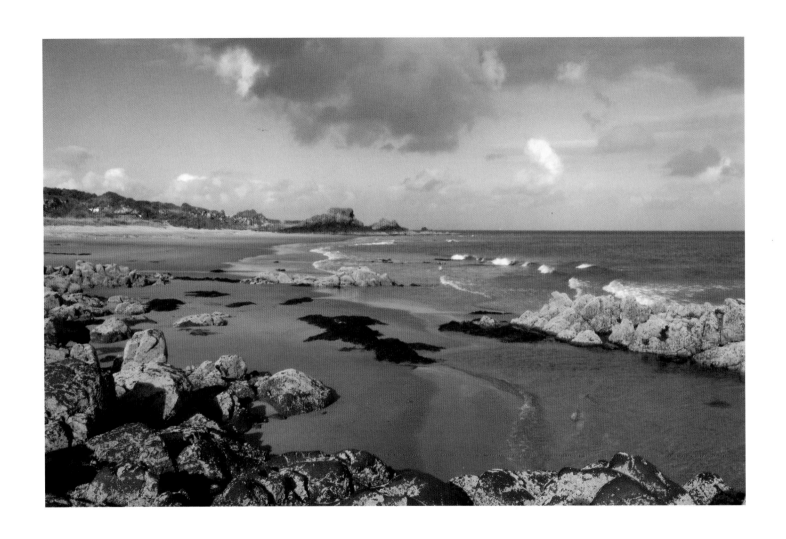

Southend beach, Mull of Kintyre: only 20 kilometres from the Irish shore

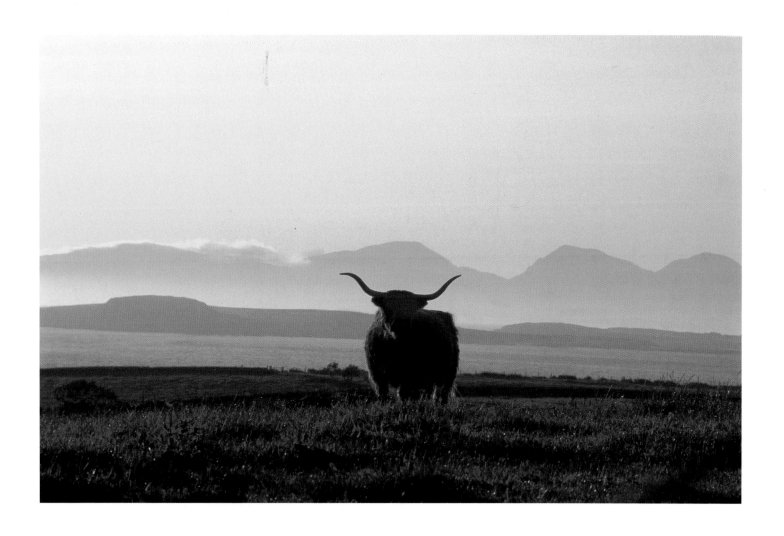

A study in summer stillness – horns set against the distant Paps of Jura

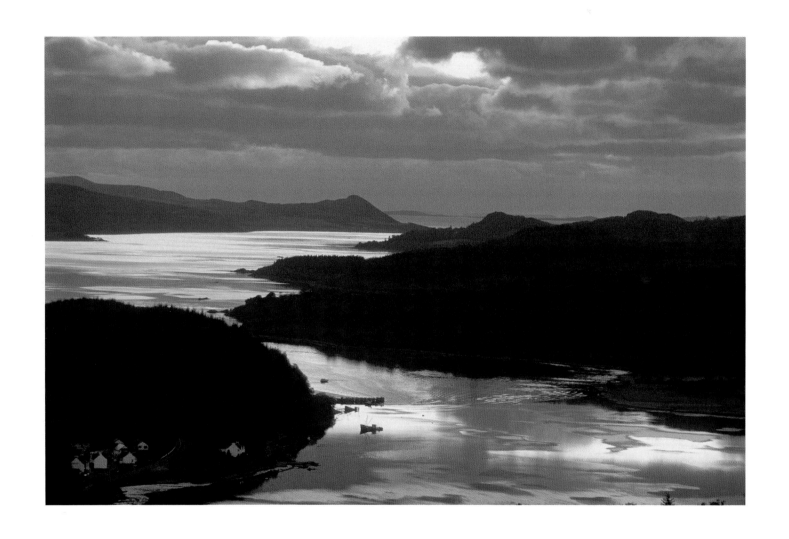

The view from West Loch Tarbert looking towards Islay

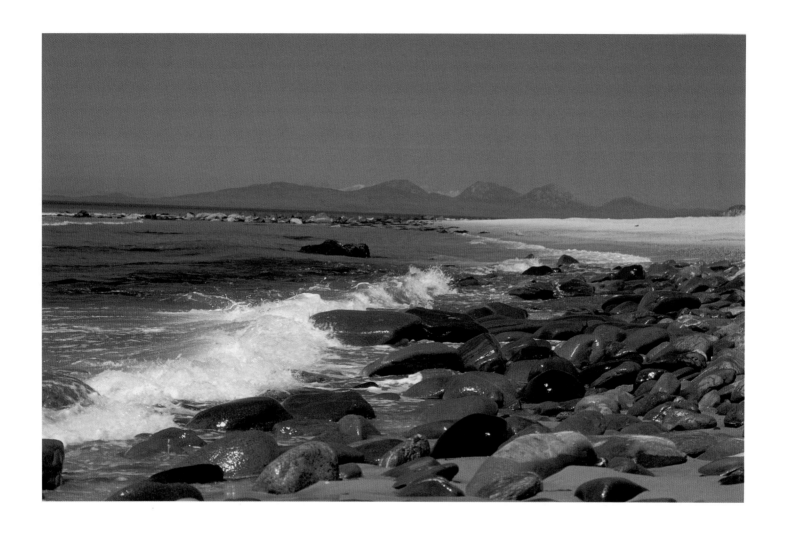

The Paps of Jura are a constant sight on the horizon from any spot on the west of the Kintyre peninsula. They are seen here from Bellochantuy Bay.

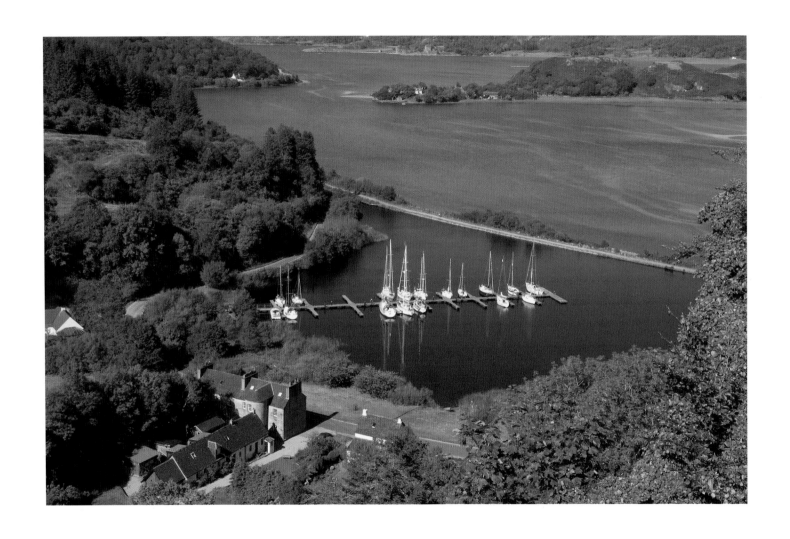

Bellanoch with Loch Crinan. A five span iron bridge was erected here in 1851 to cross the River Add.

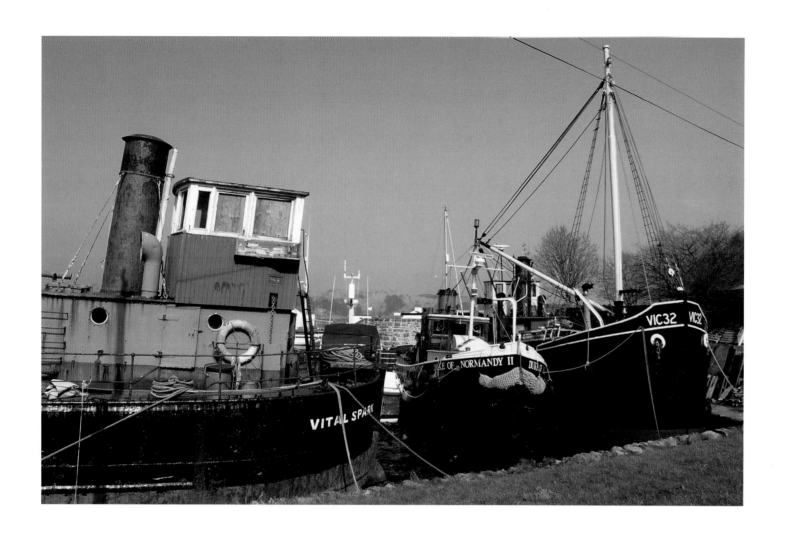

Puffers – the last of the breed – in Crinan Basin. The puffer, immortalised by Inveraray born Neil Munro in his Para Handy stories – remains one of the ubiquitous images of Argyll and the West Coast.

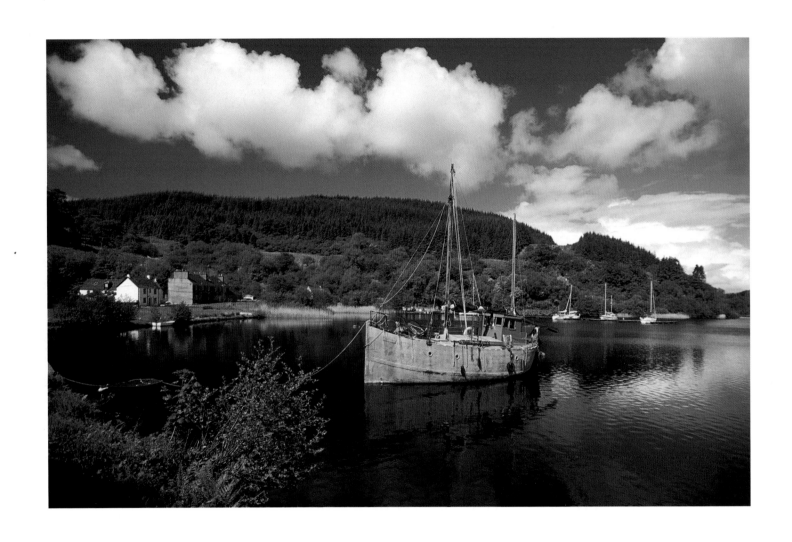

Bellanoch – on her mooring an antique trawler converted into a house boat

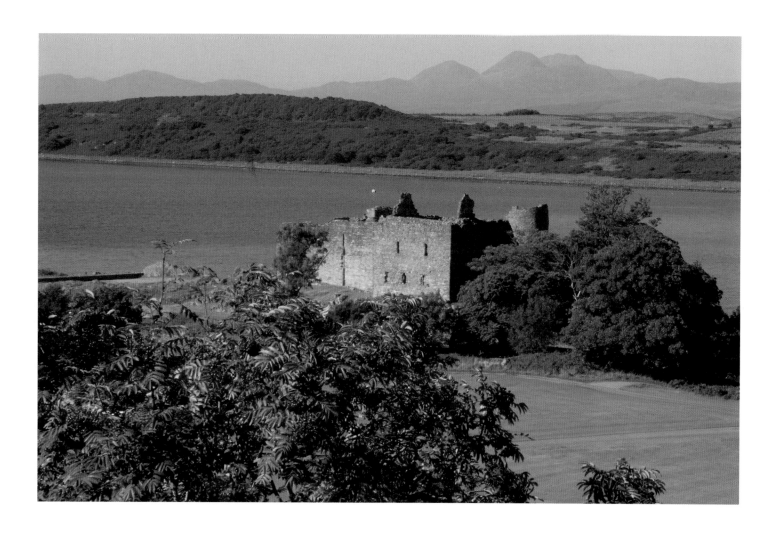

Castle Sween and the Paps of Jura

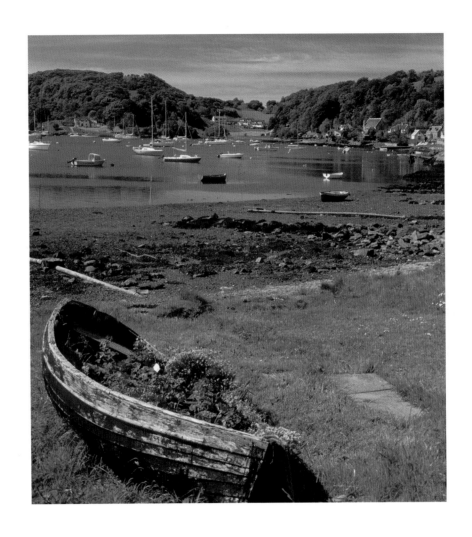

Tayvallich: Once a hamlet where primitive ferries sailed to Jura – now a settlement for tourism and yachting

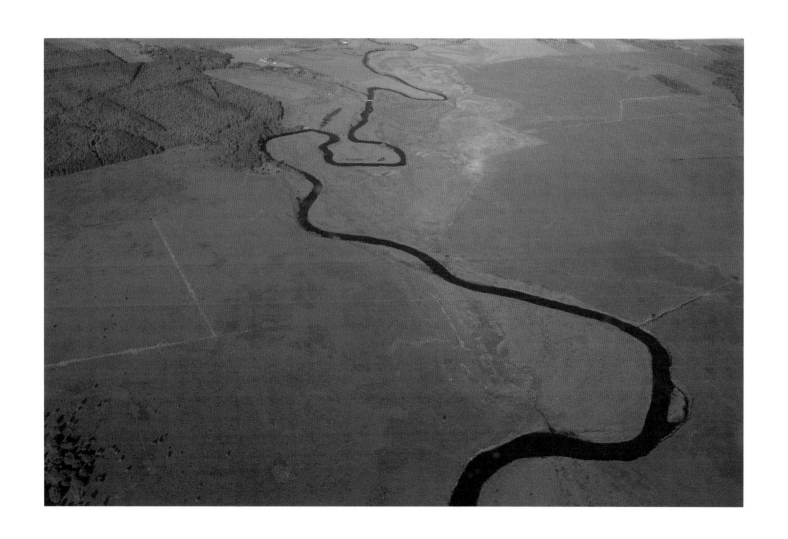

Moine Mhor – Crinan Moss, a low lying area where peat is still being formed

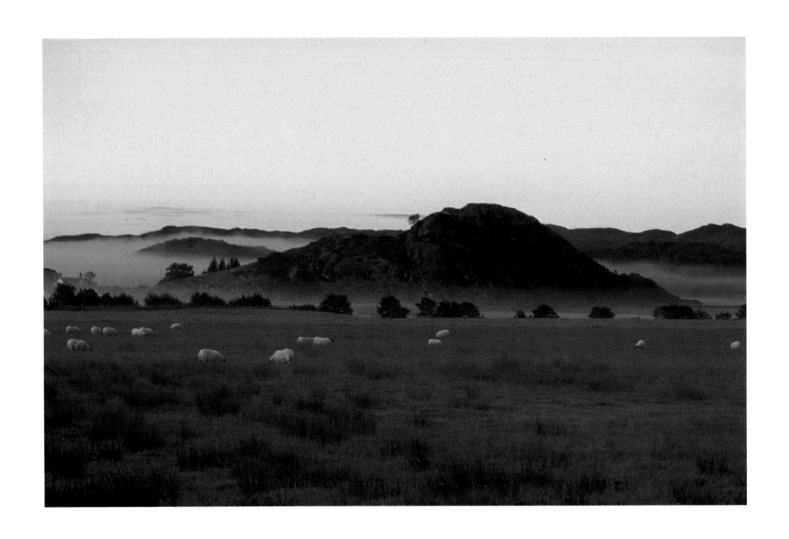

Morning mist at Dunadd the home of Scottish kingship and the heartland of the Scottish nation

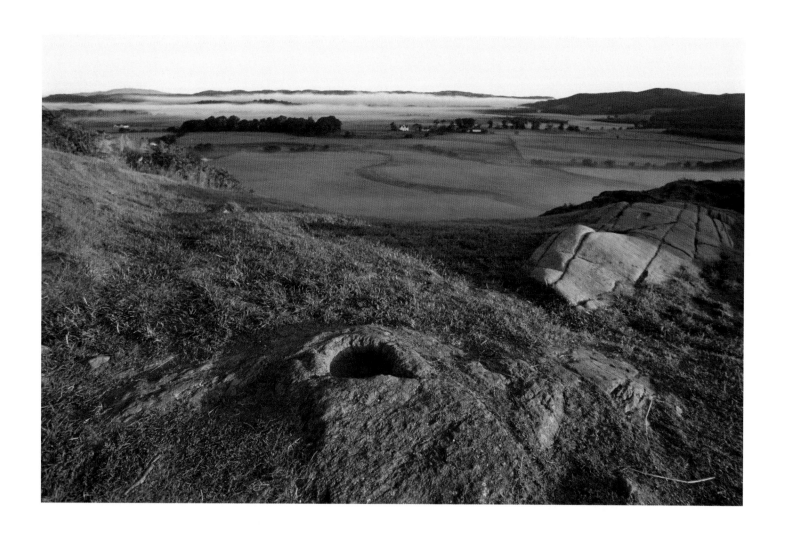

Dunadd: from this site the eye is drawn towards Kilmartin, whose ancient glen emerges in the morning from summer mist

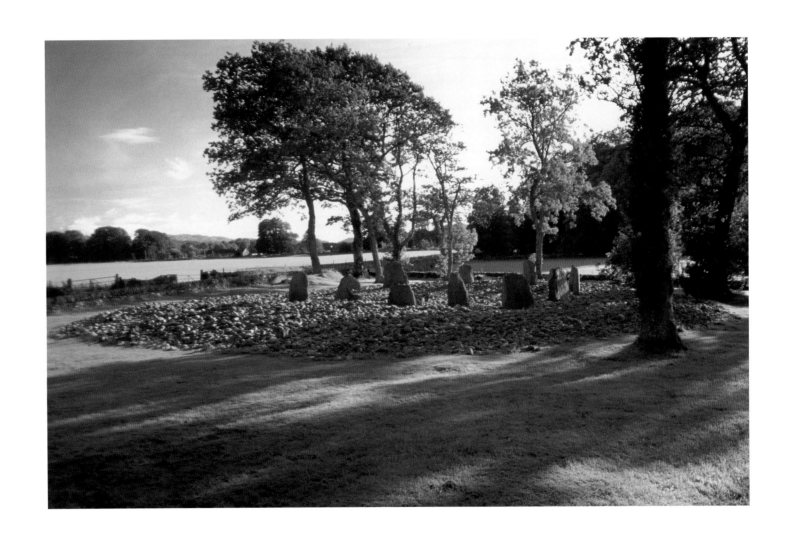

Stone Circle, Templewood, Kilmartin. The Glen contains one of the richest concentration of ancient sites in Scotland, and is home to an award winning interpretative centre and museum, recently saved from closure.

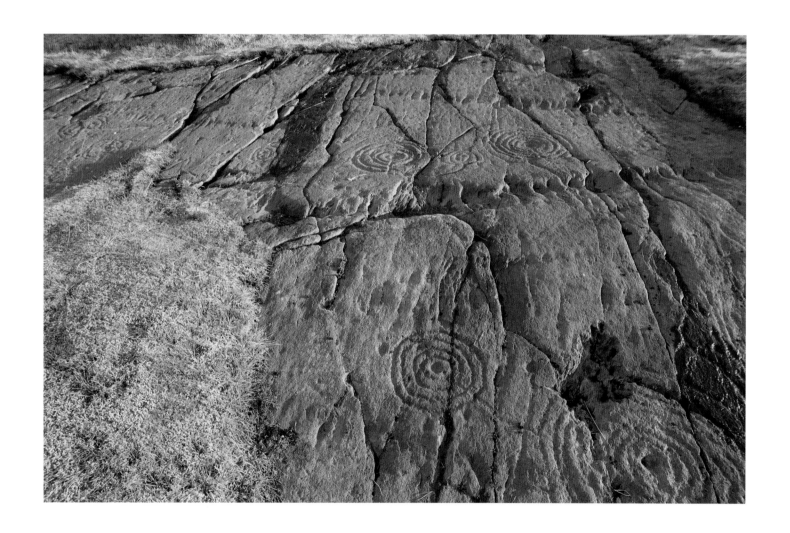

Cup and Ring Marks, Achnabreck. Whilst the Kilmartin area has what is almost an abundance of this type of very ancient rock carving, there is no agreement on what it means or why it was done.

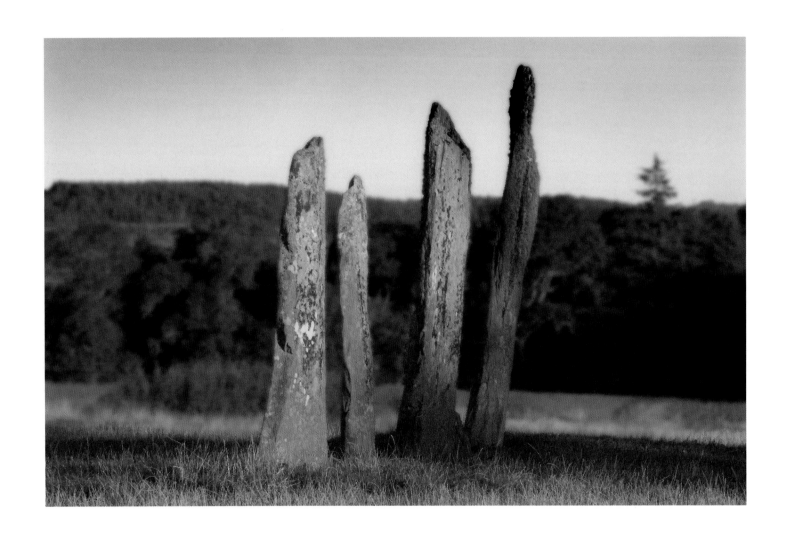

4 fang-like standing stones in the heart of ancient Kilmartin Glen

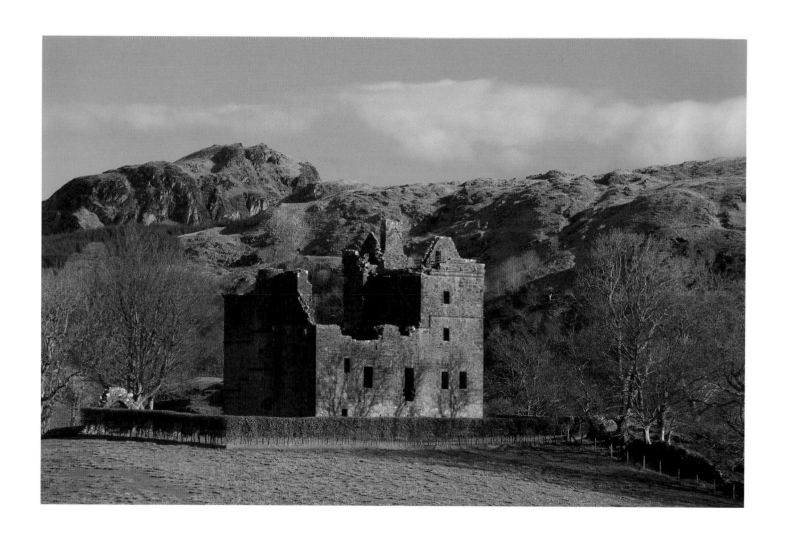

Carnasserie Castle which was destroyed by Royalist forces in 1685, after its owner joined the Earl of Argyll in opposing them

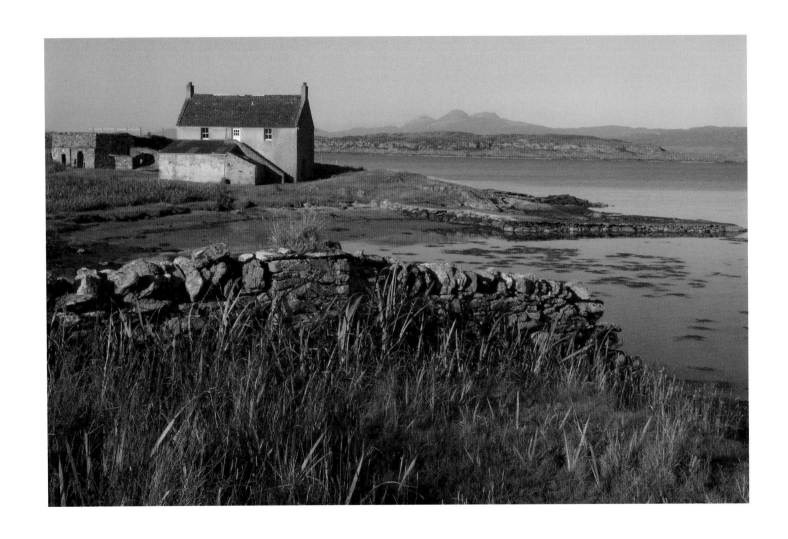

Danna island, Knapdale which is not a true island, but a peninsula separated by a channel which dries out at low water

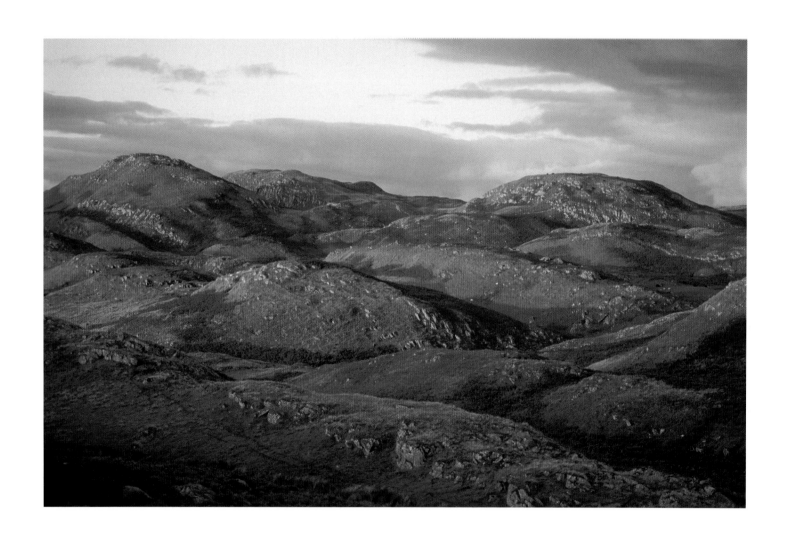

Hill pasture, Slockavullin, Kilmartin

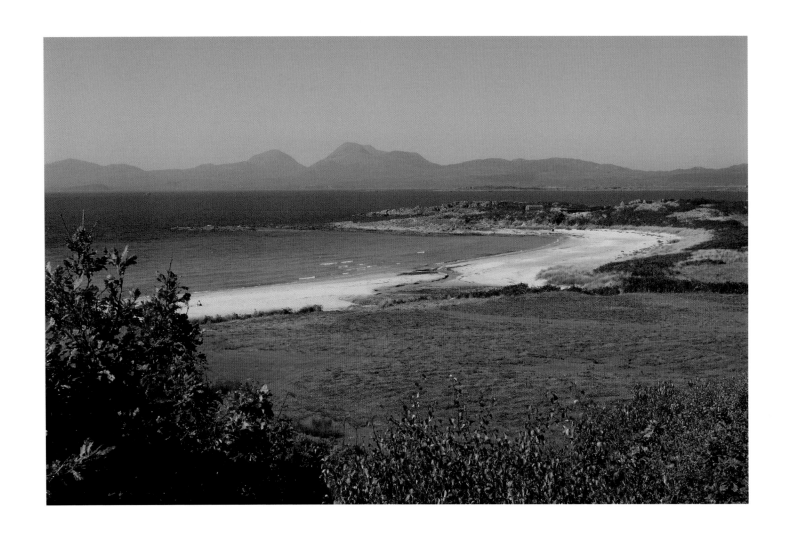

Kilmory Bay, Knapdale

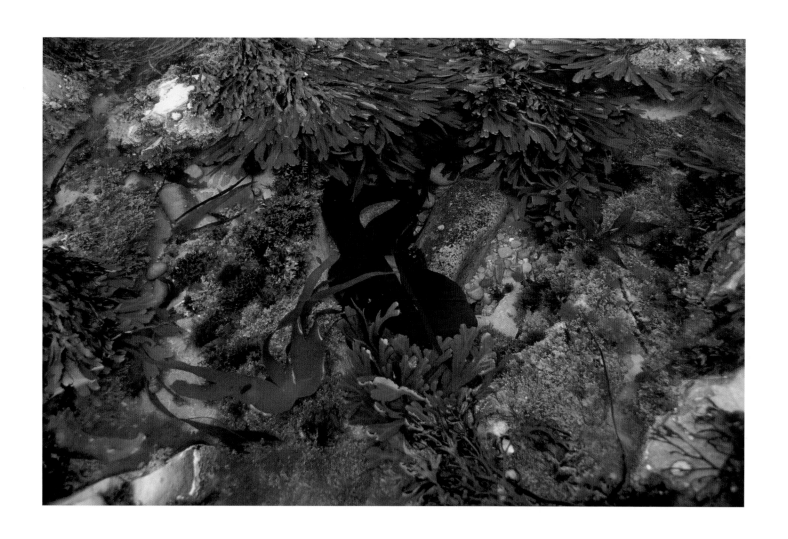

Rockpool, Knapdale

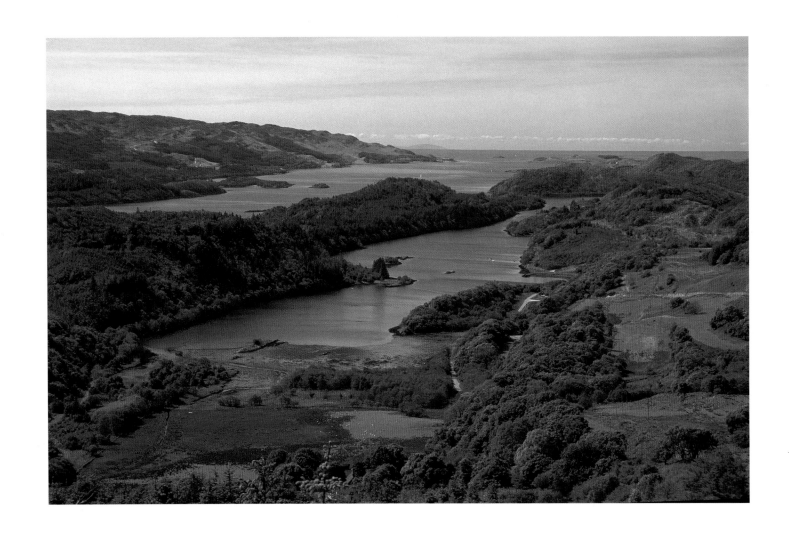

Knapdale, Loch Sween and the Knapdale forest which may soon host the first ever re-introduction of beavers to Scotland

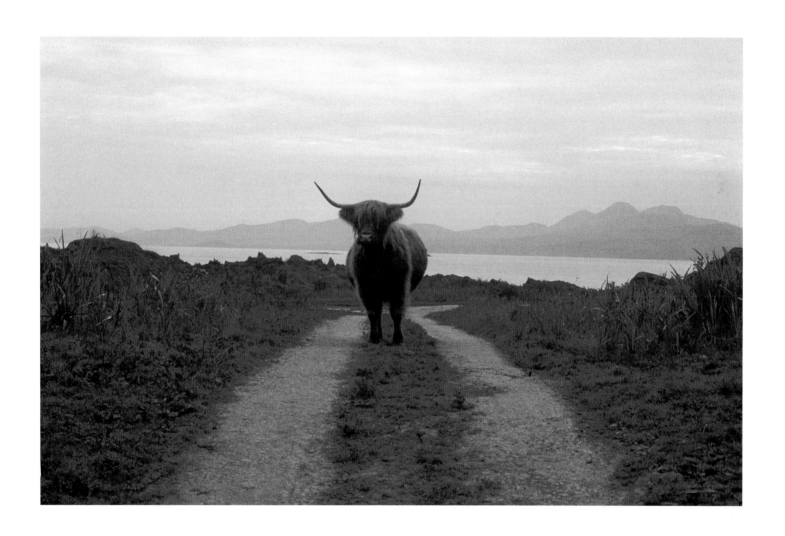

A traditional guardian on the road to the isles: Keil Point, Knapdale, with Jura in the background

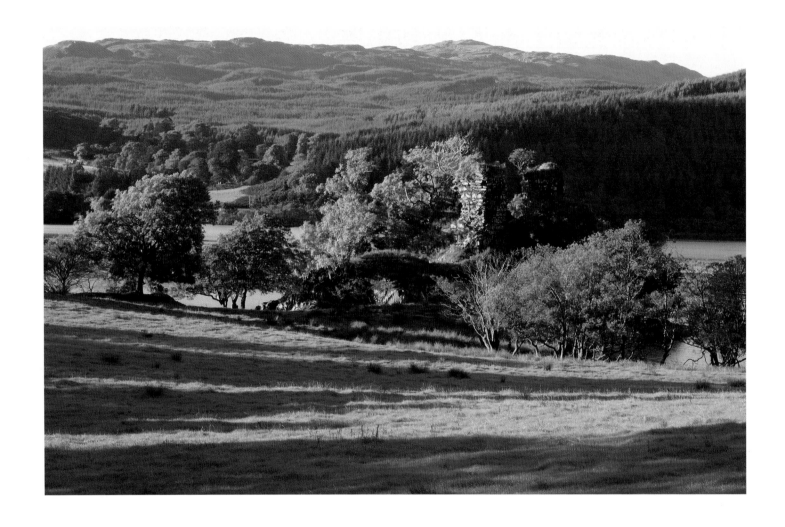

The ruins of Fincharn castle, Loch Awe

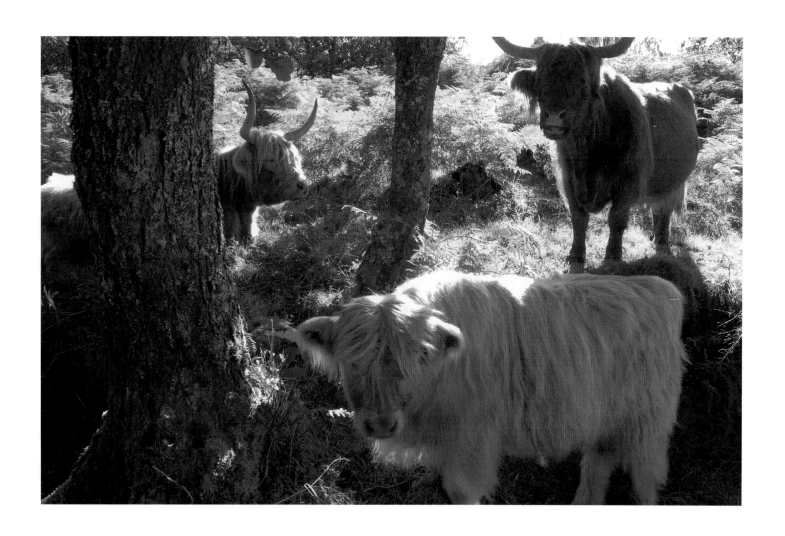

Shade on a summer's day – Portsonachan, Loch Awe

Went here

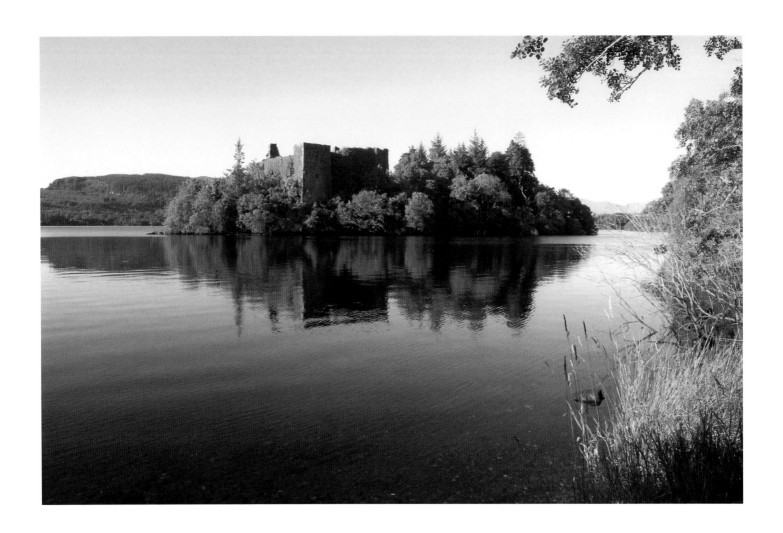

Innischonnel castle, Loch Awe. An island stronghold, in which the wife of Angus Og was held captive by the Argyll family.

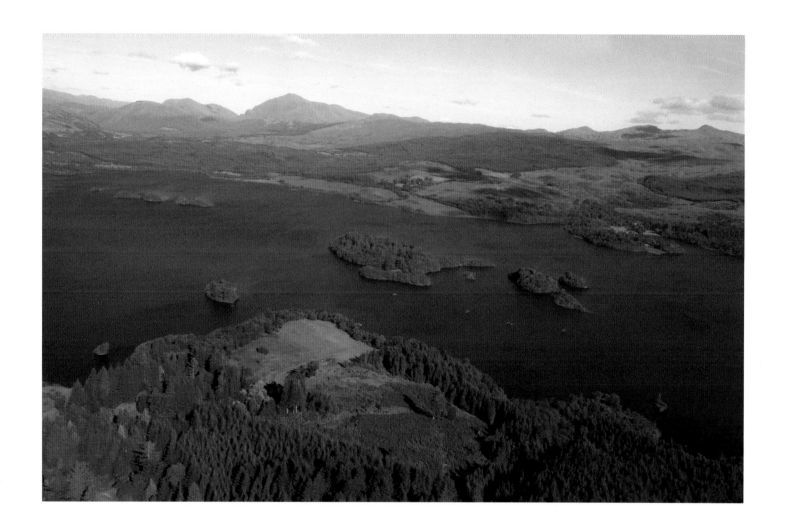

Argyll's largest inland stretch of water Loch Awe from above Ardanaiseaig

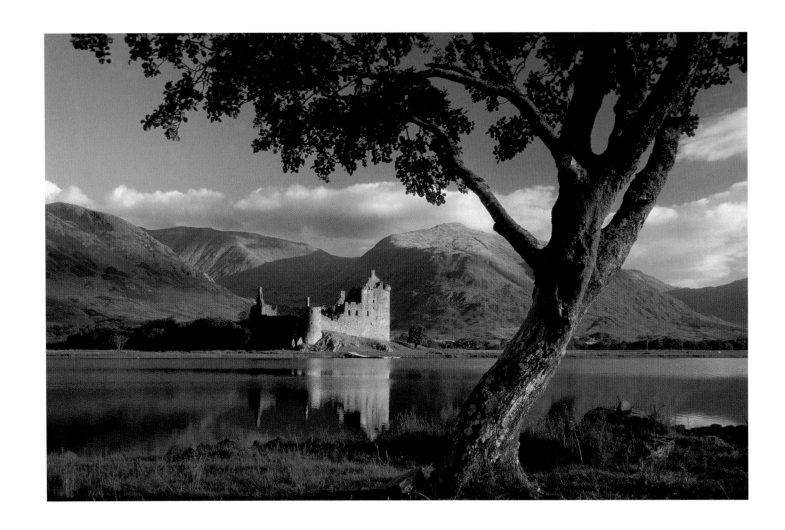

A classic view of Scotland's second most photographed castle – Kilchurn on Loch Awe. Having endured 250 years of occupation and constant building, and 250 years of neglect, the castle is now ruined but much visited. The last owners, the Earls of Breadalbane, moved to Taymouth in the eighteenth century and a lightening strike destroyed the roof in 1769.

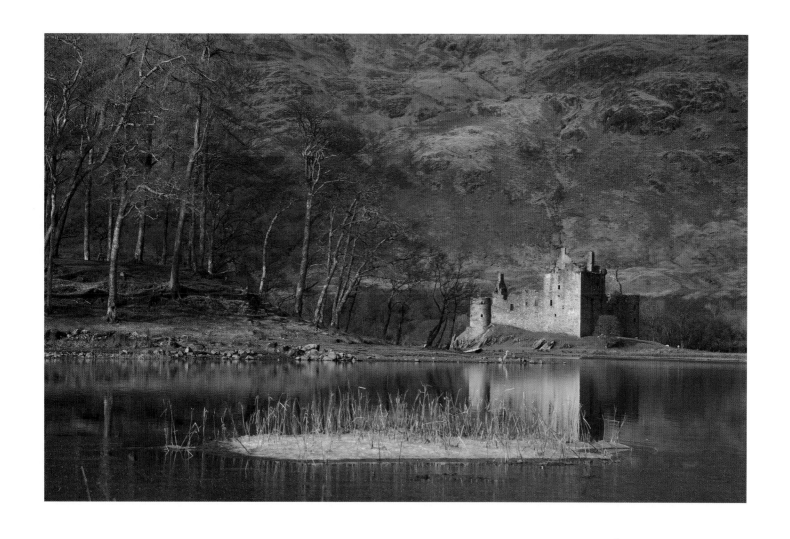

Kilchurn in mid-winter

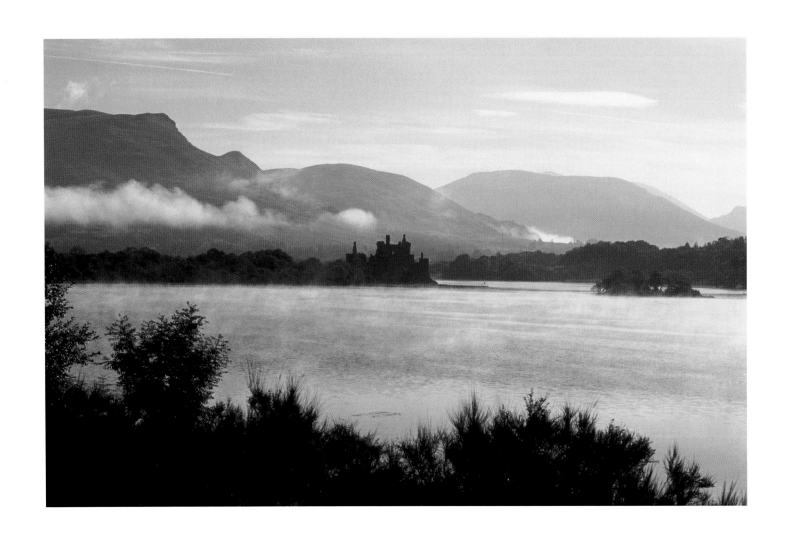

....and in a morning mist, adding to the romance!

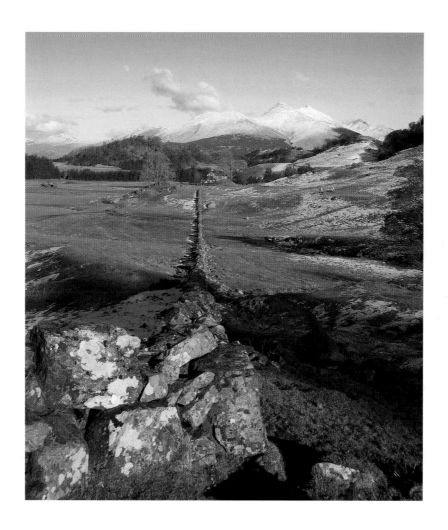

Ben Cruachan from Glen Lonan. The Glen was part of the burial route of Scottish Kings, taken to be interred on Iona.

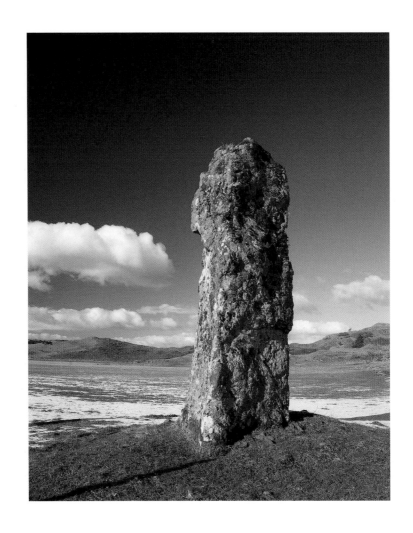

Strontoiller, Glen Lonan

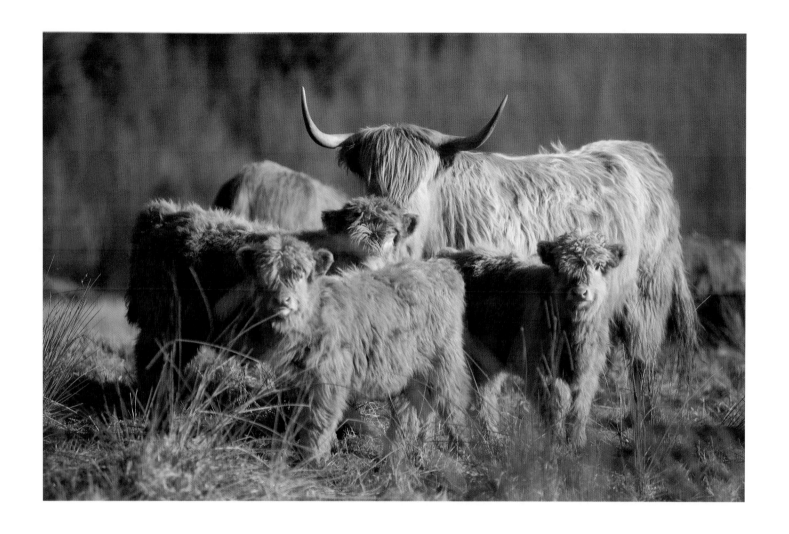

Highland Cattle, Glen Lonan

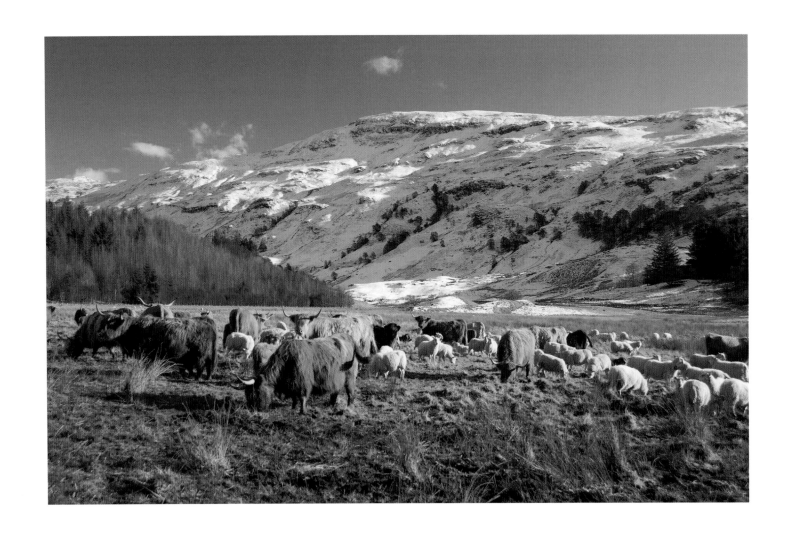

Large herds of cattle and sheep gather for late winter feeding – Glen Lonan

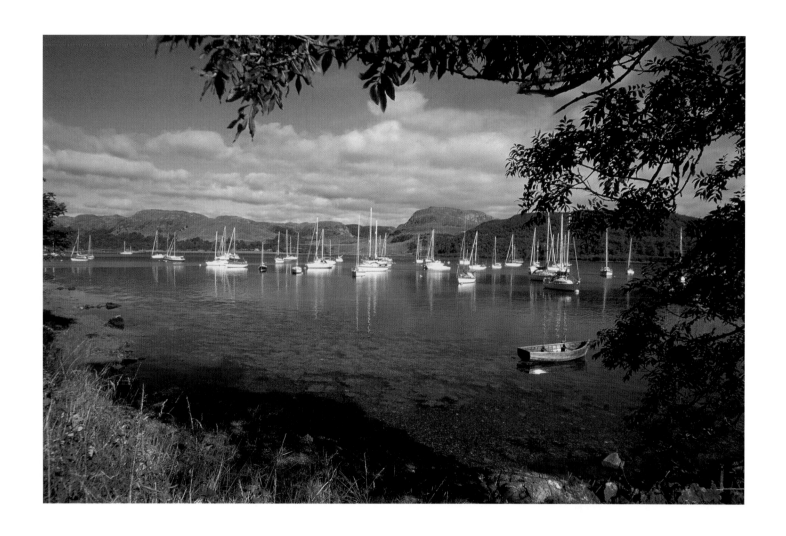

Moorings at Ardfern, another popular yachting haunt

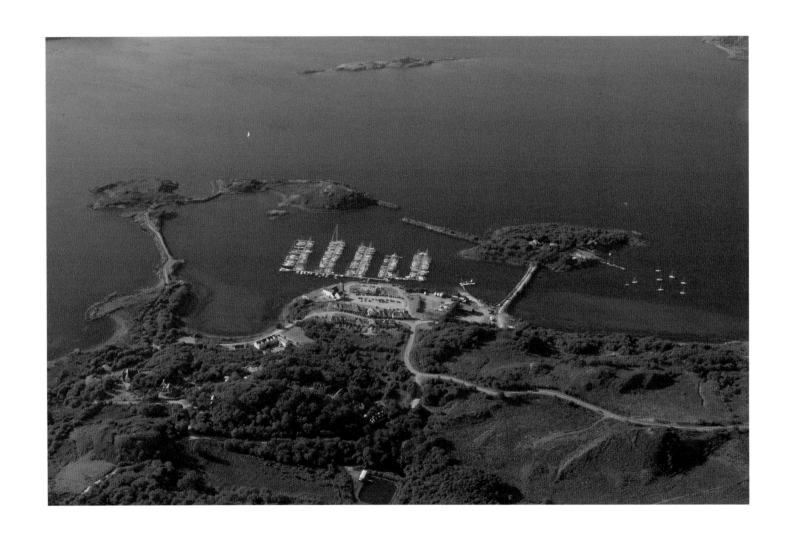

Craobh Haven, a marina and holiday complex established in 1983 and now very popular with yachtsmen and tourists

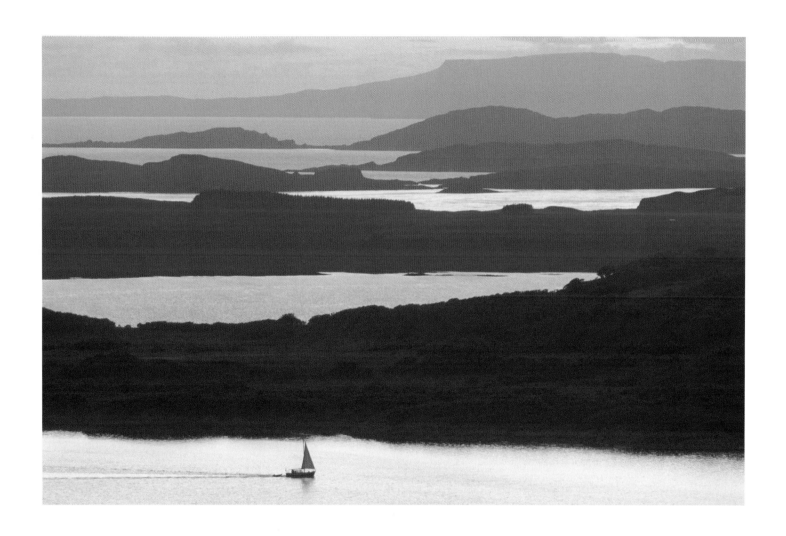

Homeward bound to the yacht harbour at Craobh Haven, with the islands of Shuna, Luing and Mull all visible

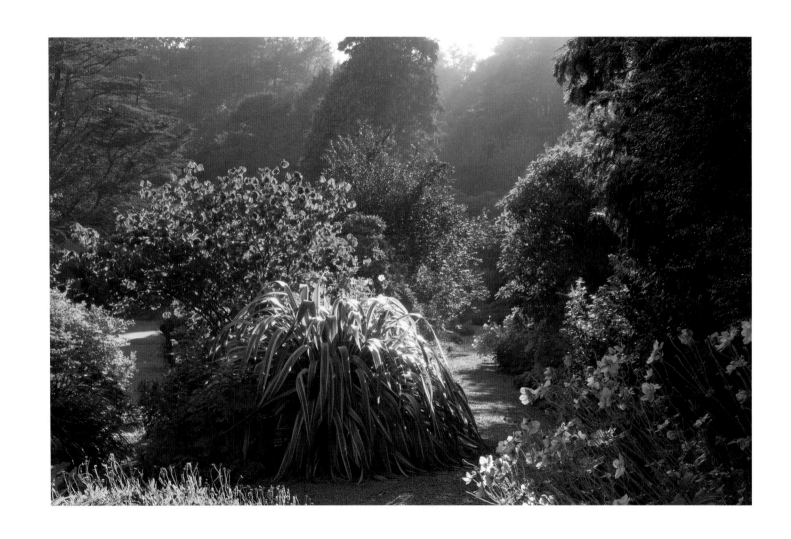

Arduaine Gardens near Oban – a sheltered 20 acres now in the care of the National Trust for Scotland

A rowan, often planted to ward off witches, seen here at Kilmelford

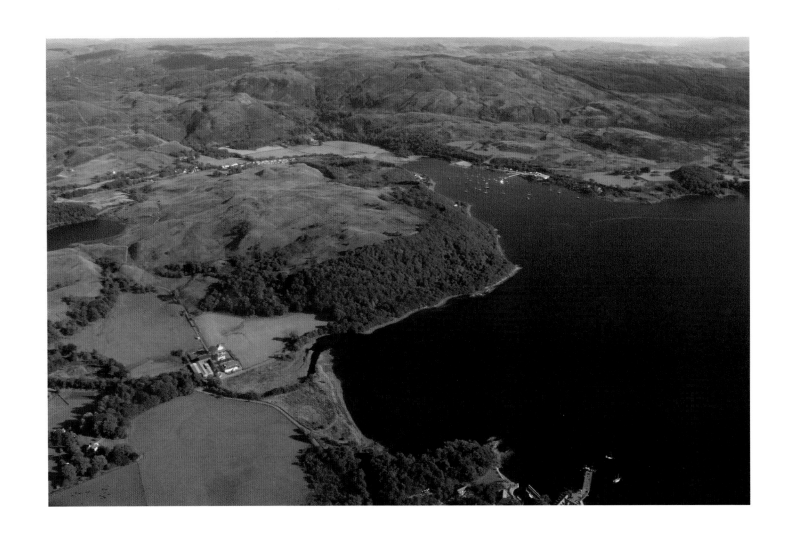

Loch Melfort from the air. The fjord-like nature of the Argyll coastline is clearly seen.

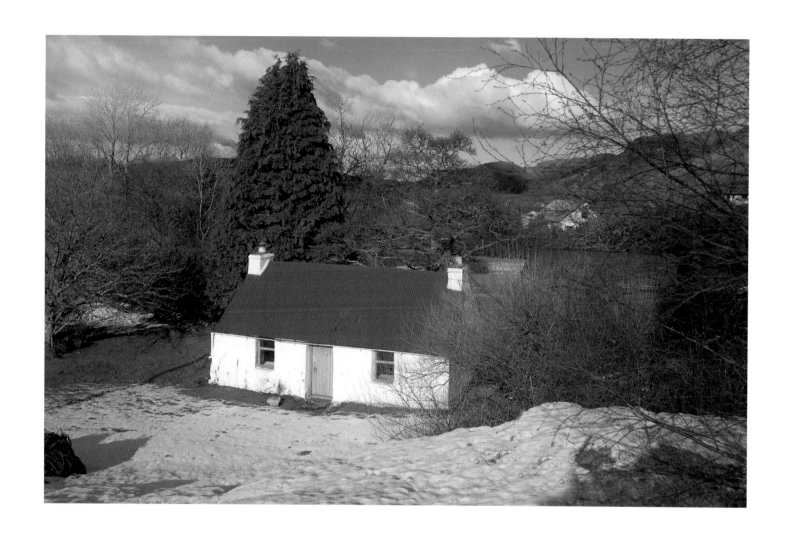

Cleigh, south of Oban

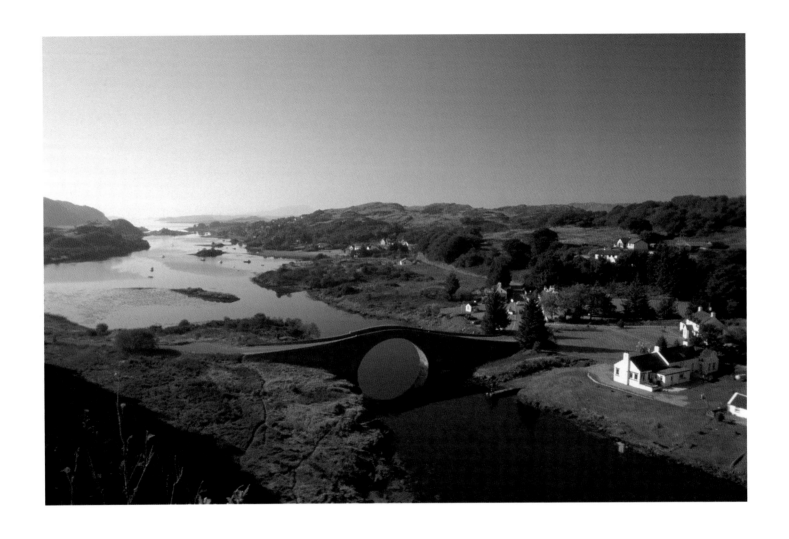

The "Bridge over the Atlantic", built in 1792 to join the Seil Island to the rest of Scotland

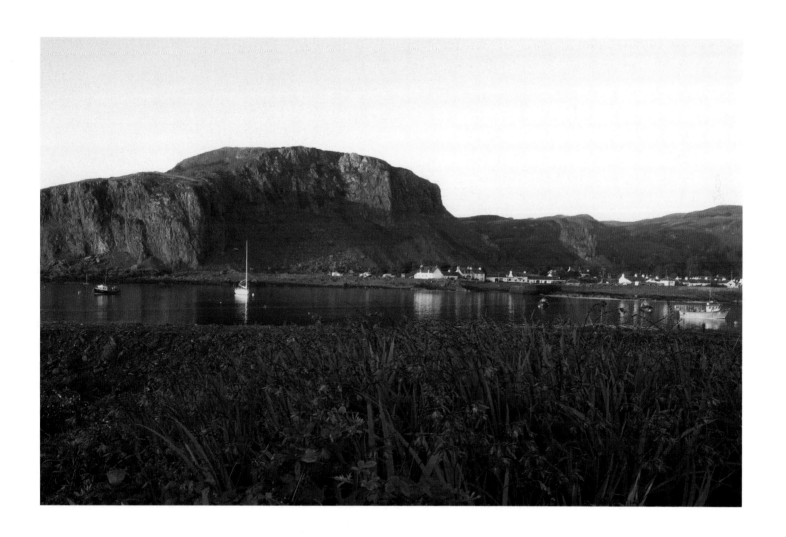

Late sun on Easdale island. The small settlement nestles beneath ancient "Dun Mor" – the "big fort". The island – the smallest inhabited one In the Inner Hebrides – was a major centre for slate quarrying until a storm in 1881 flooded the quarries. Reduced to a population of four by the 1950s, the island now has 60 residents and a confident, outward looking population.

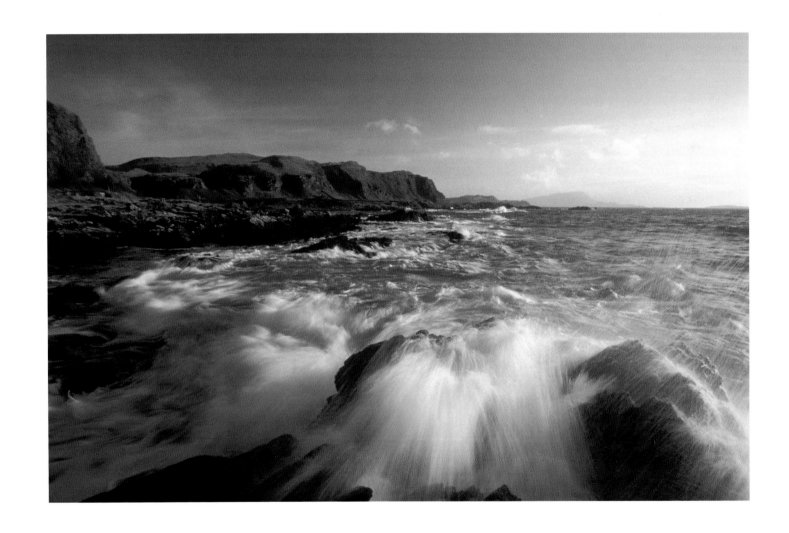

The Atlantic is the ever present sound and smell of the westward shores, crashing into, or caressing the islands and bays at different times of year, as here at Easdale in winter

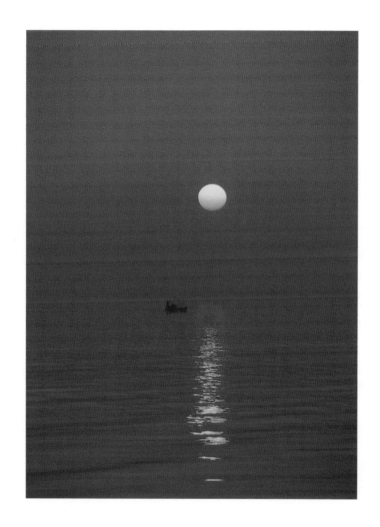

Bringing the catch home – Kilbrannan Sound

Went here

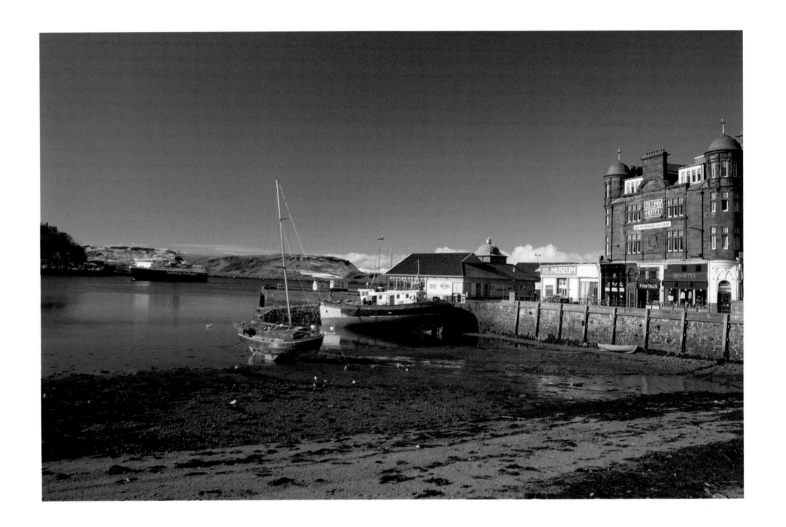

A crisp morning on Oban beach

Went here

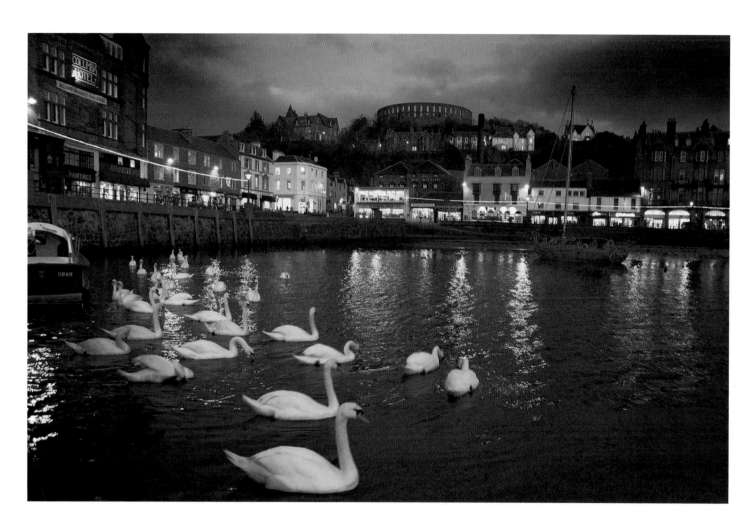

Oban swans on a late summer evening

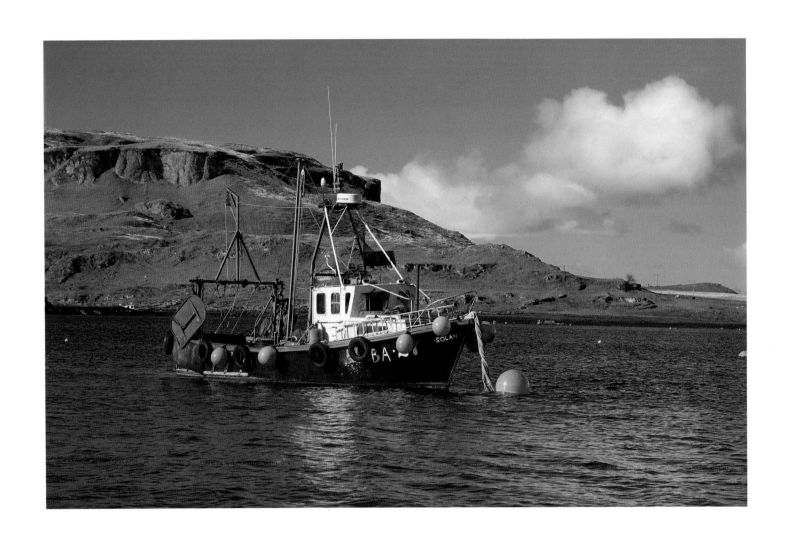

A inshore fishing boat, moored in the Sound of Kerrera

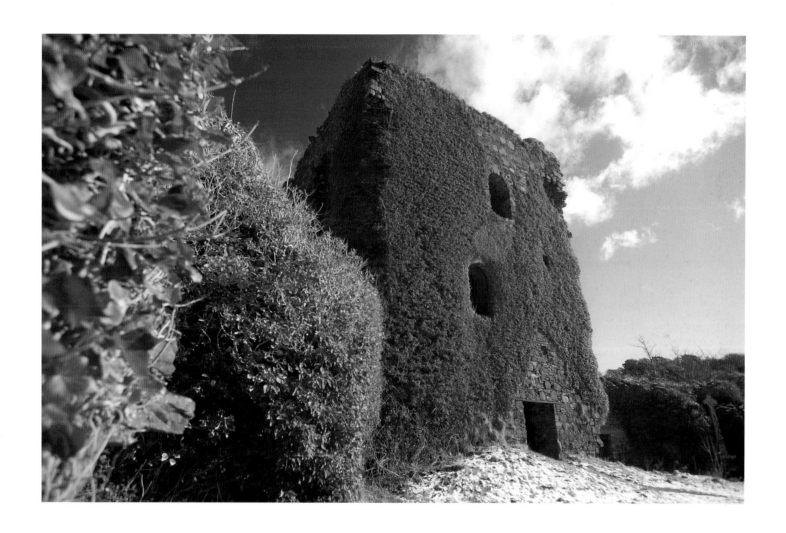

Dunollie Castle which dates from the 12th century

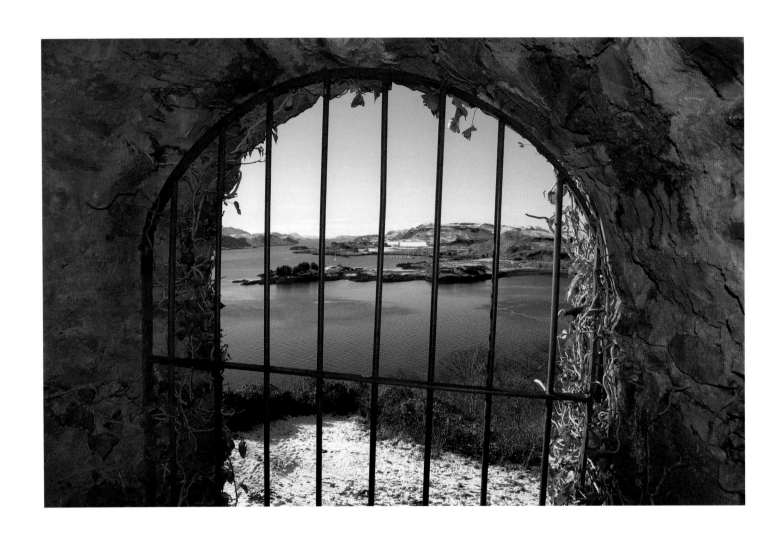

Looking towards the island of Kerrera from Dunollie Castle

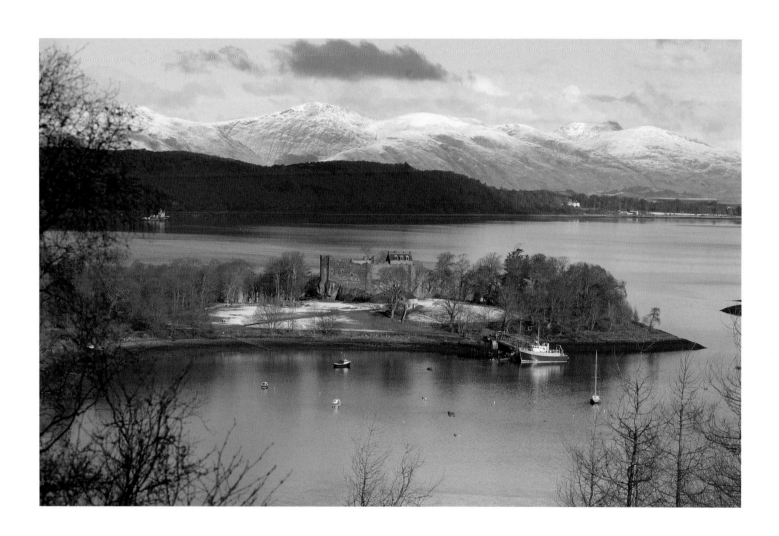

Dunstaffnage Castle and the mountains of Morvern and Ardgour

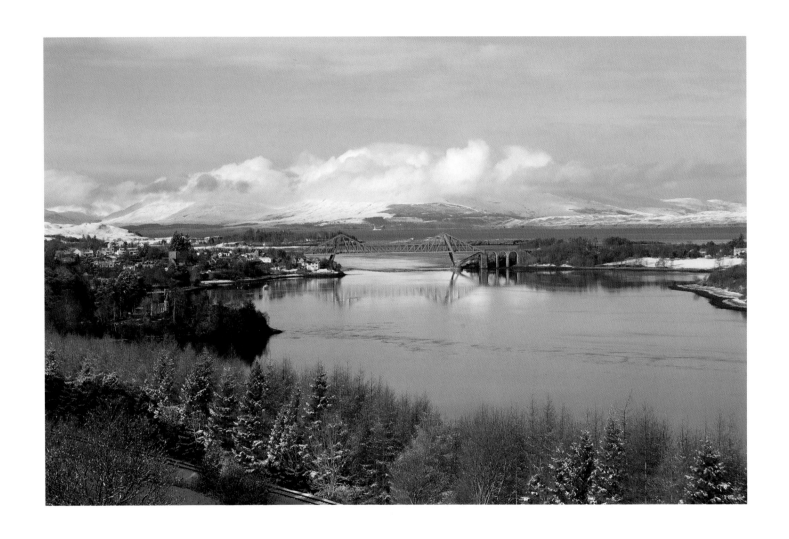

Connel Bridge; built in 1903 for the Caledonian Railway, it was converted to a road bridge when the line closed in 1963

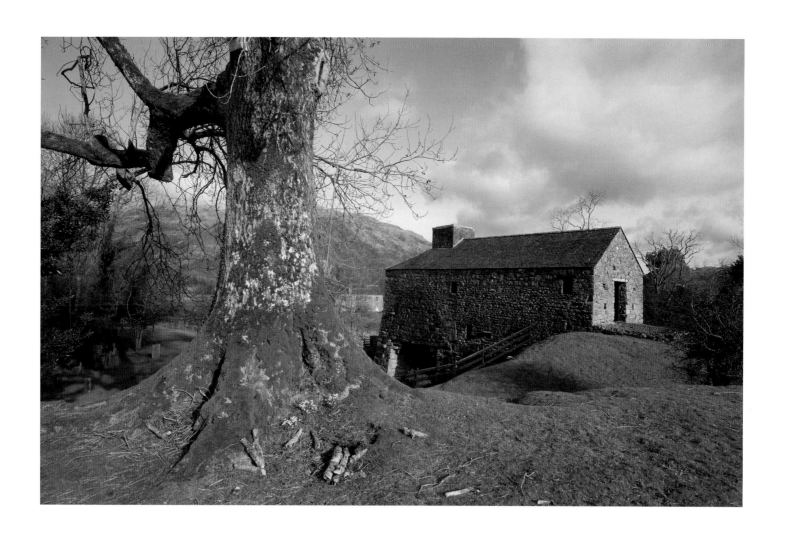

Bonawe iron works, Taynuilt. Founded in 1753 by a Lake District Partnership it remains the most complete charcoal fuelled ironworks in Britain and is managed by Historic Scotland.

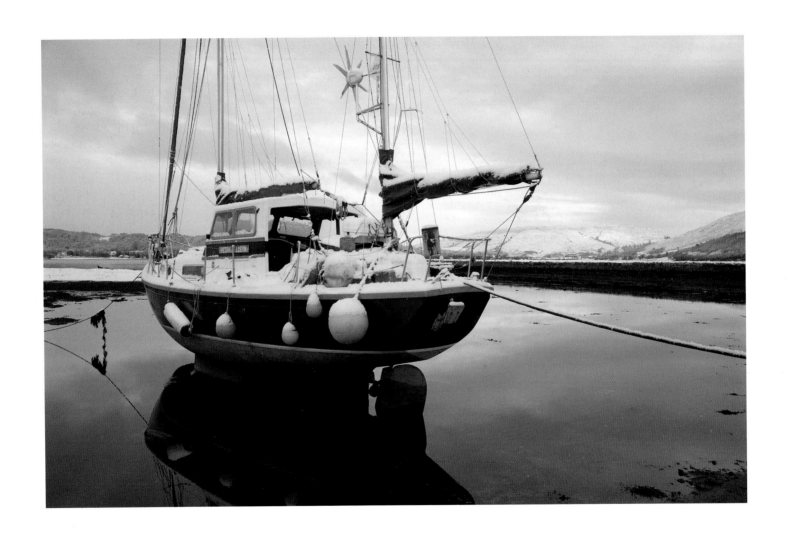

Snow at Taynuilt, Loch Etive

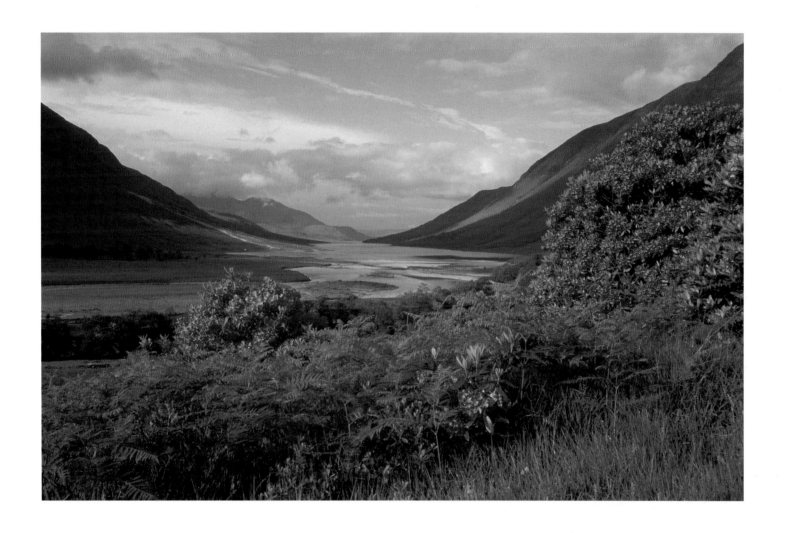

Loch Etive in spring, with abundant evidence of the invasive effect of Rhododendron Ponticum, seen everywhere in Argyll at this time of year

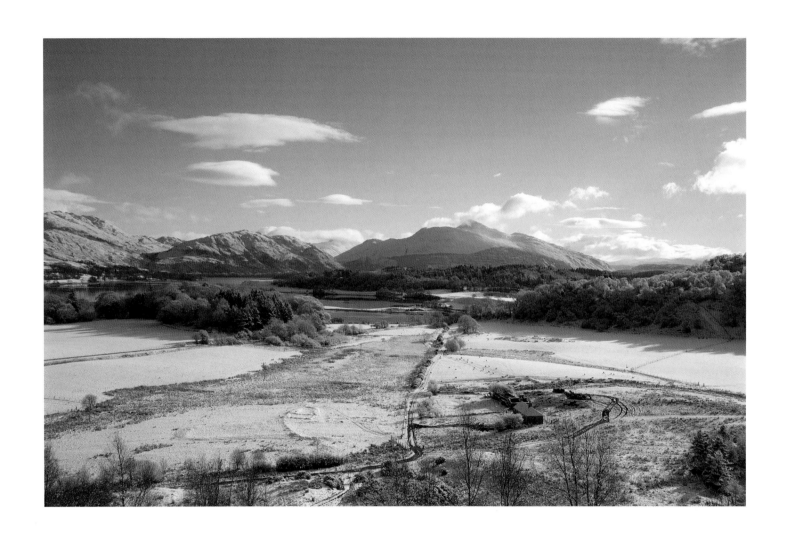

Ben Cruachan and Loch Etive in winter

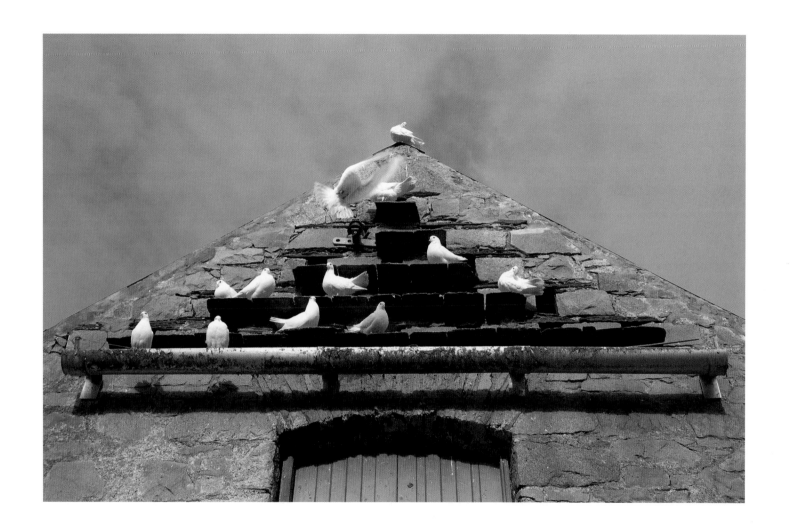

Doves at Ardchattan Priory near Oban: founded by the strict Valliscaulian Order in 1230, it ceased its monastic function in 1545 at the time of the Scottish Reformation. The ruins feature some fine carved stones, though some of the building is still a residence. The grounds contain another Argyll garden worth visiting.

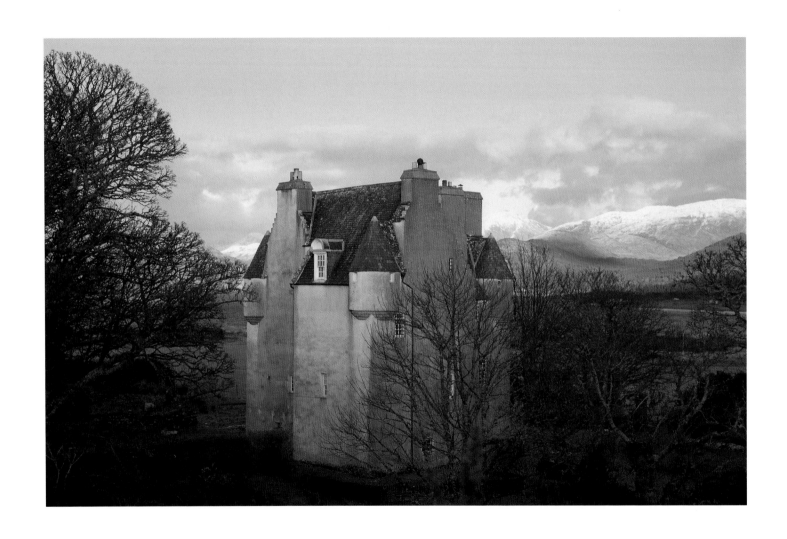

Barcaldine Castle: the name in Gaelic means "Hazel Knoll". It was built by Campbells in the 16th century and was known as the "Black Castle of Benderloch". Sold as a ruin in 1842, the Campbell family bought in back in 1896 and restored it.

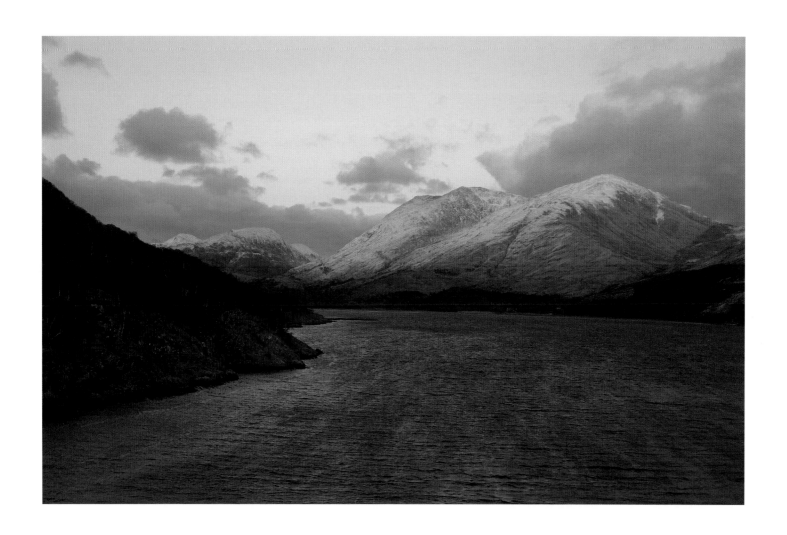

A low sun shines coldly on Creach Bheinn and Loch Creran

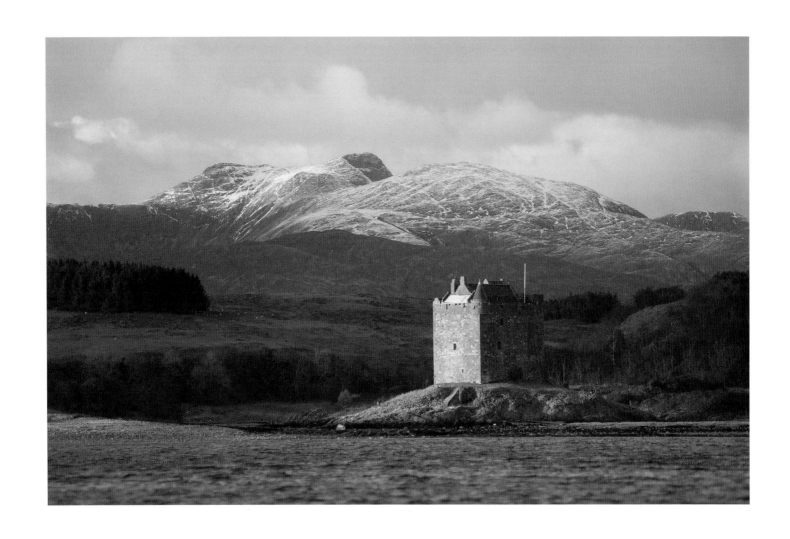

Castle Stalker – the Castle of the Hunter built by the Stewarts of Appin in the fifteenth century – stands starkly out against the wintry mountains of Ardgour

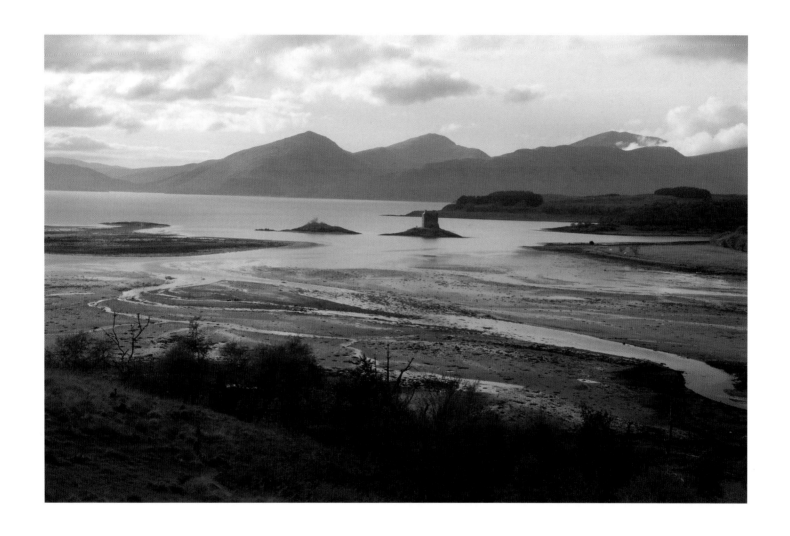

Loch Linnhe

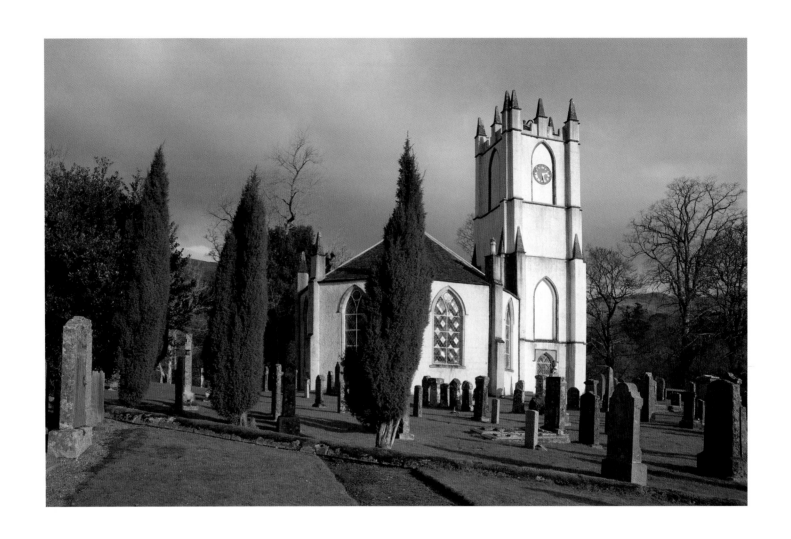

Dalmally Church, which dates from the early part of the 19th century

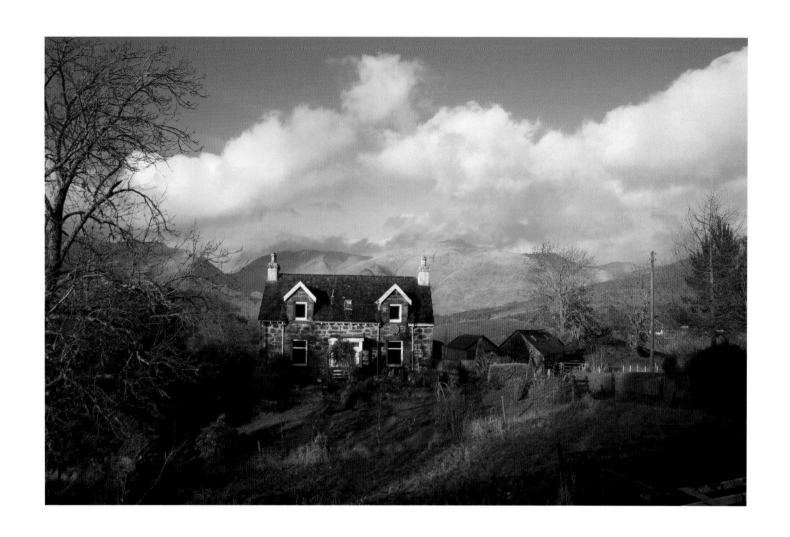

Traditional cottage by Croftintuime, above Dalmally

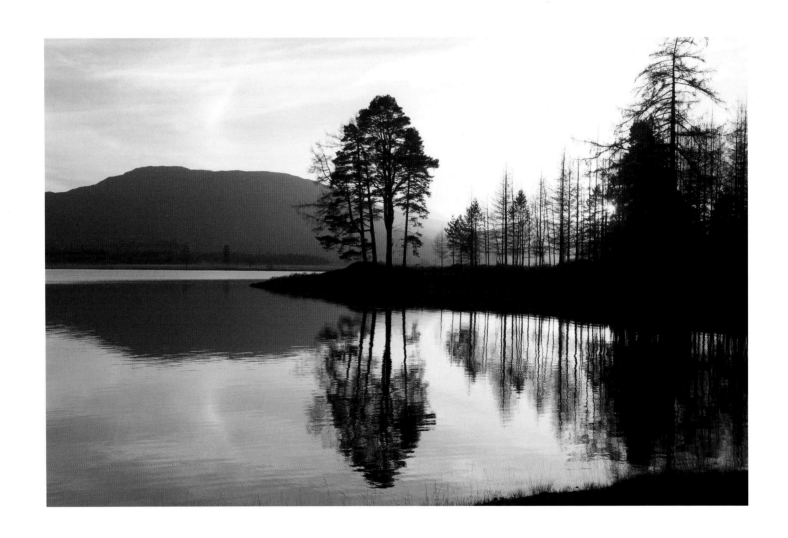

Sunset on larches, Loch Tulla

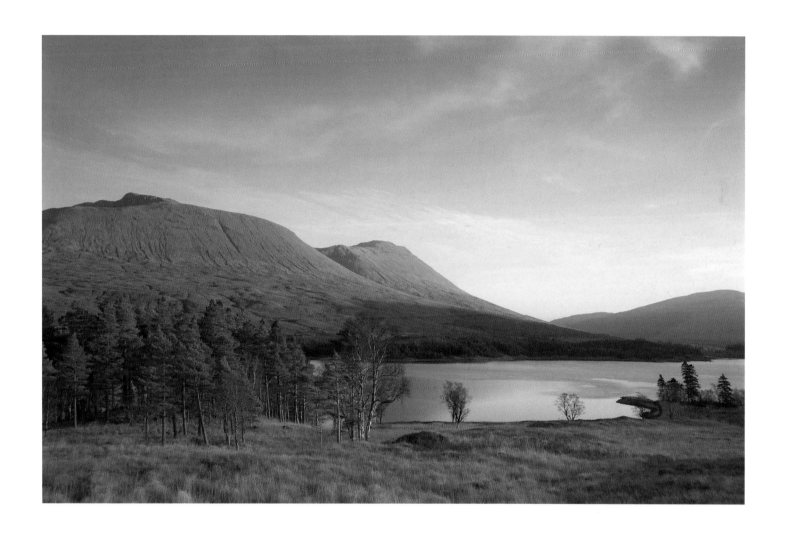

Loch Tulla looking to Ben Dothaidh and Ben Dorain

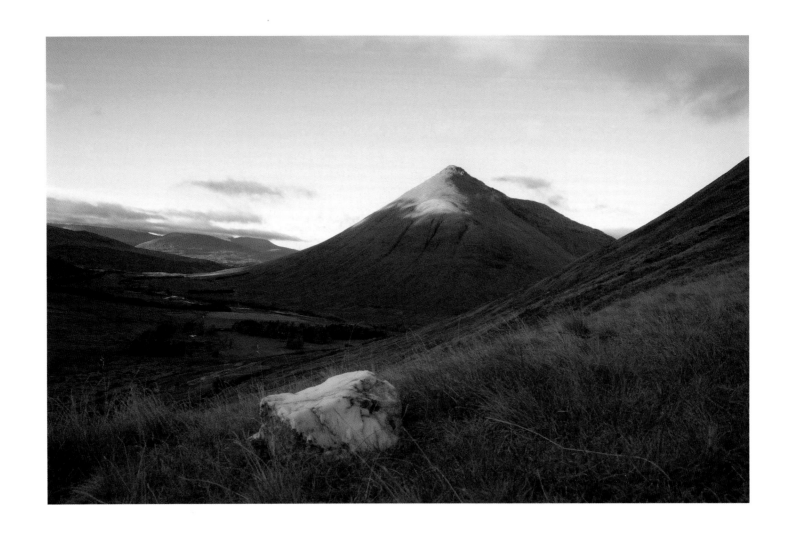

Ben Dorain, which is a classic walk for those equipped for the vagaries of Scottish mountain weather

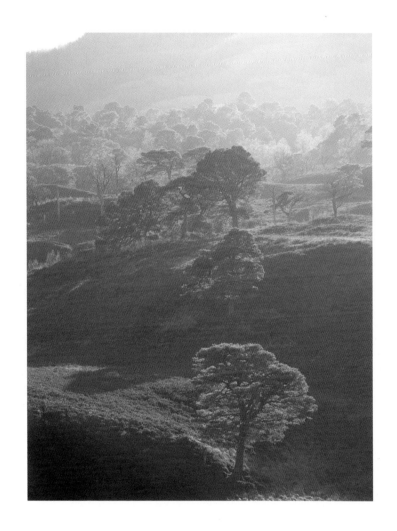

A stray remnant of ancient Caledonian woodland at Dalrigh, Tyndrum

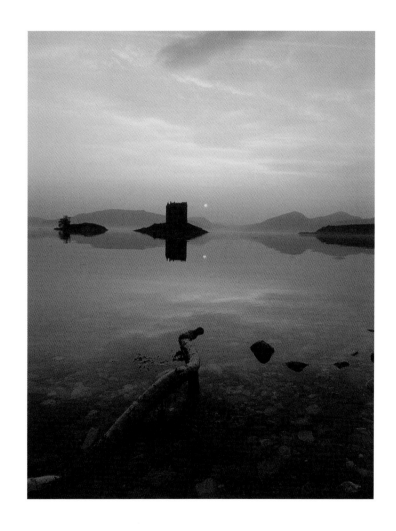

The lush colours of a classic west of Scotland sunset